Mother Nature's Best Side A Picture Journey

Introduction

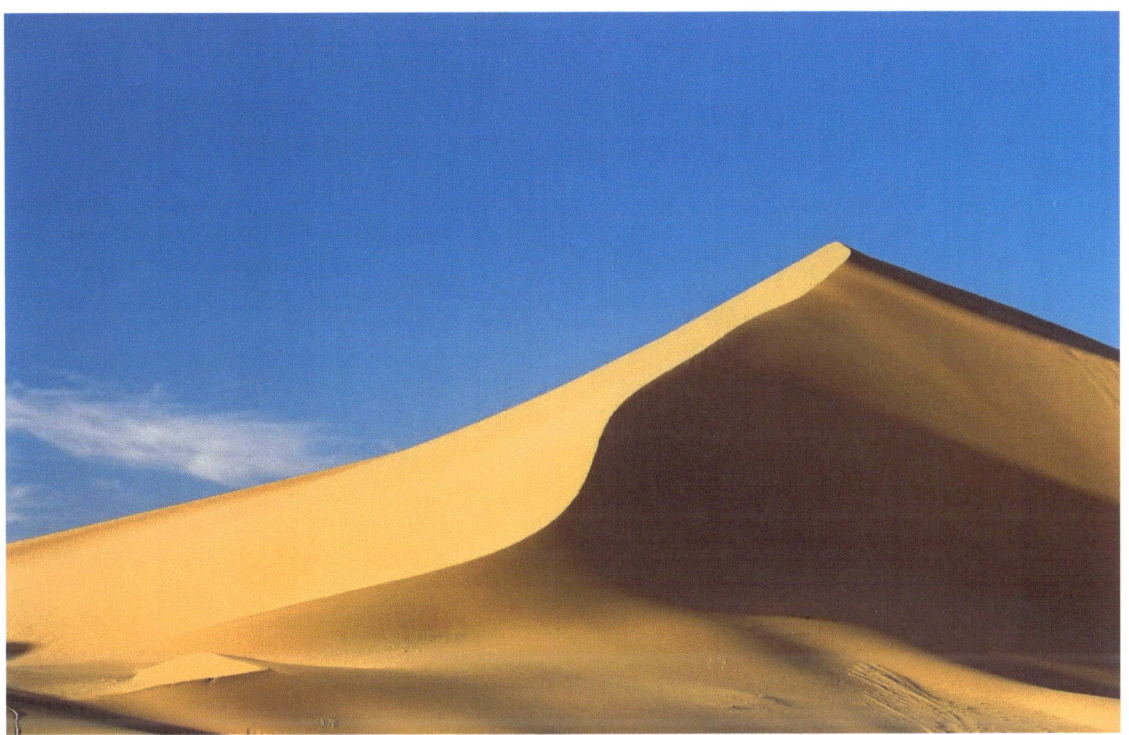

Mother Nature like the sands is always changing.
Mother Nature it is said can fill the heart with sorrow at times but at other times it can lift our spirits in ways we cannot imagine.

Journey with me as we see the wonders of nature in photographs, in all seasons and in all places across the United States.

The Road Less Traveled

We are going to start our journey where every good traveler should start
With the road less traveled.

Mother Nature's Best Side A Picture Journey

Will it be down a snowy sundrenched country lane?

Mother Nature's Best Side A Picture Journey

Or perhaps a little warmer down a dirt and gravel road to a lone tree, for no other reason but to sit in solitude.

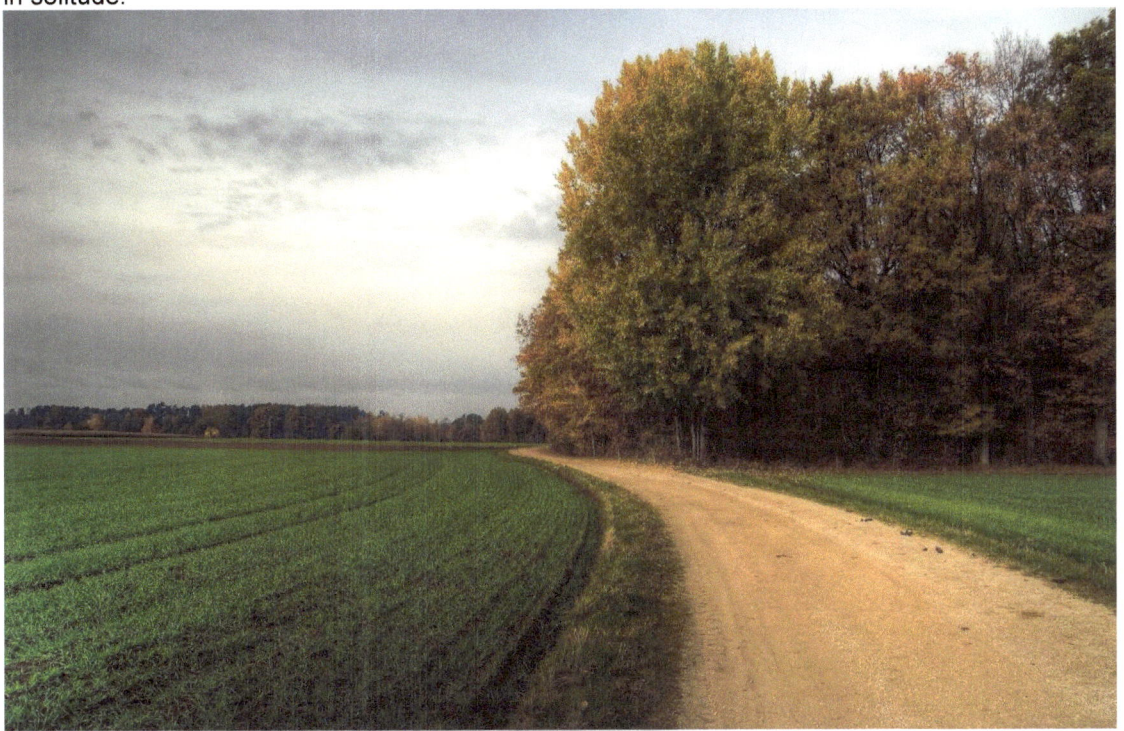

The possibilities are endless.

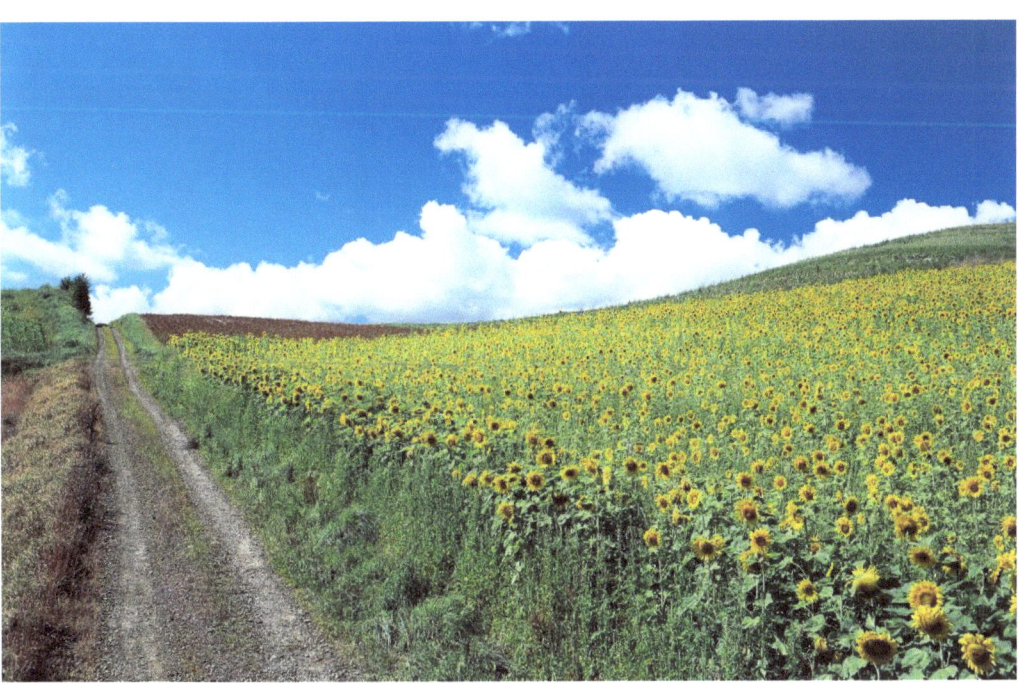

As endless as a lazy summer's day soaking up the beauty that Mother Nature offers.

Mother Nature's Best Side A Picture Journey

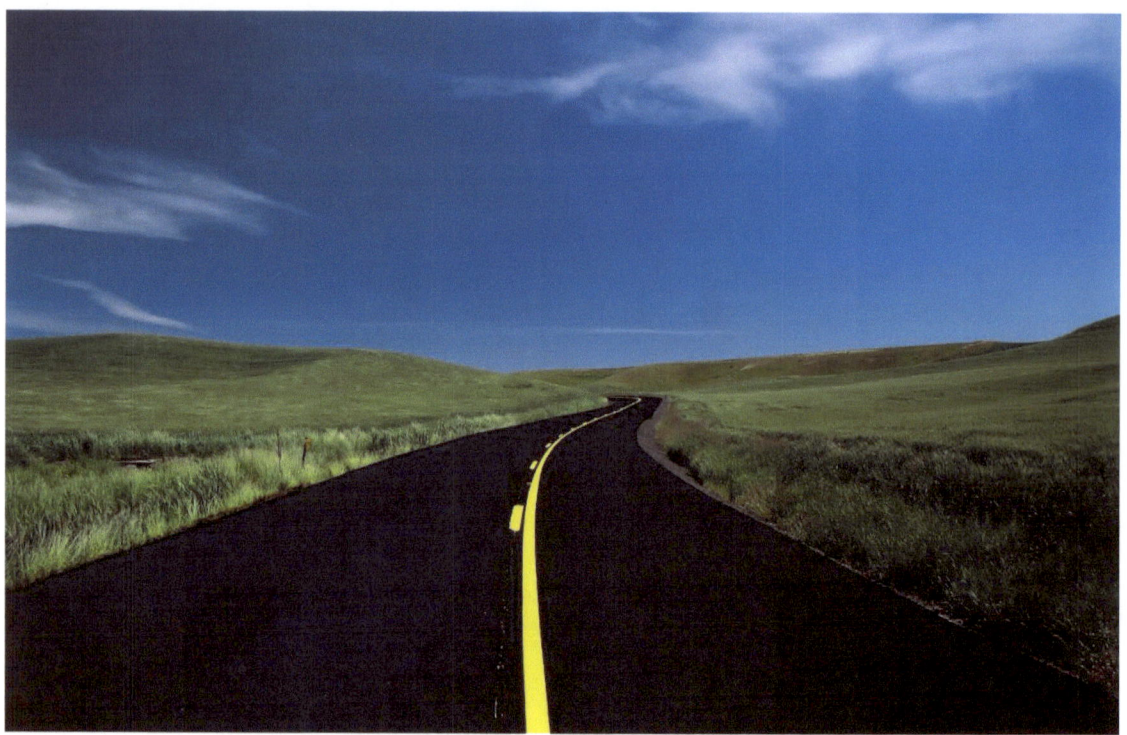

So the next time you hit the open road don't think about turning down that endless road less traveled. Seek it out.
The possibilities are truly as endless as the imagination.

Mother Nature's Best Side A Picture Journey

Stop And Smell The Flowers Along The Way

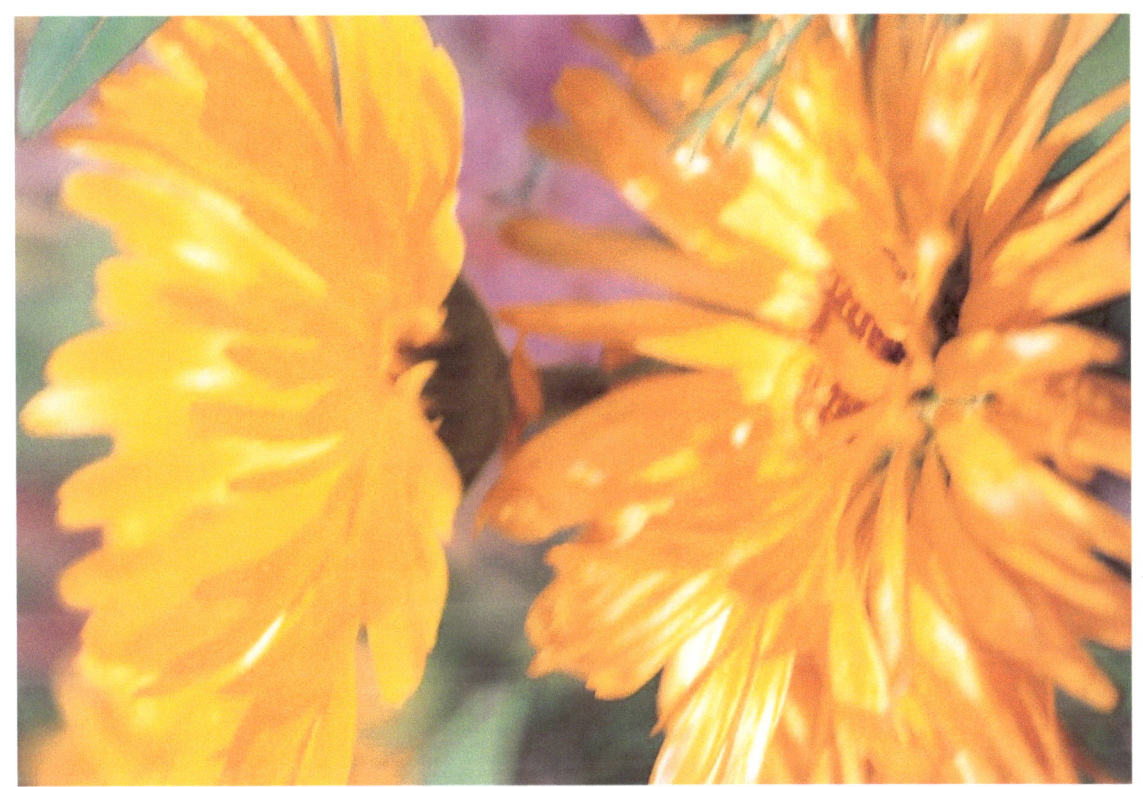

Some of Nature's brightest are also the most fragile.

Mother Nature's Best Side A Picture Journey

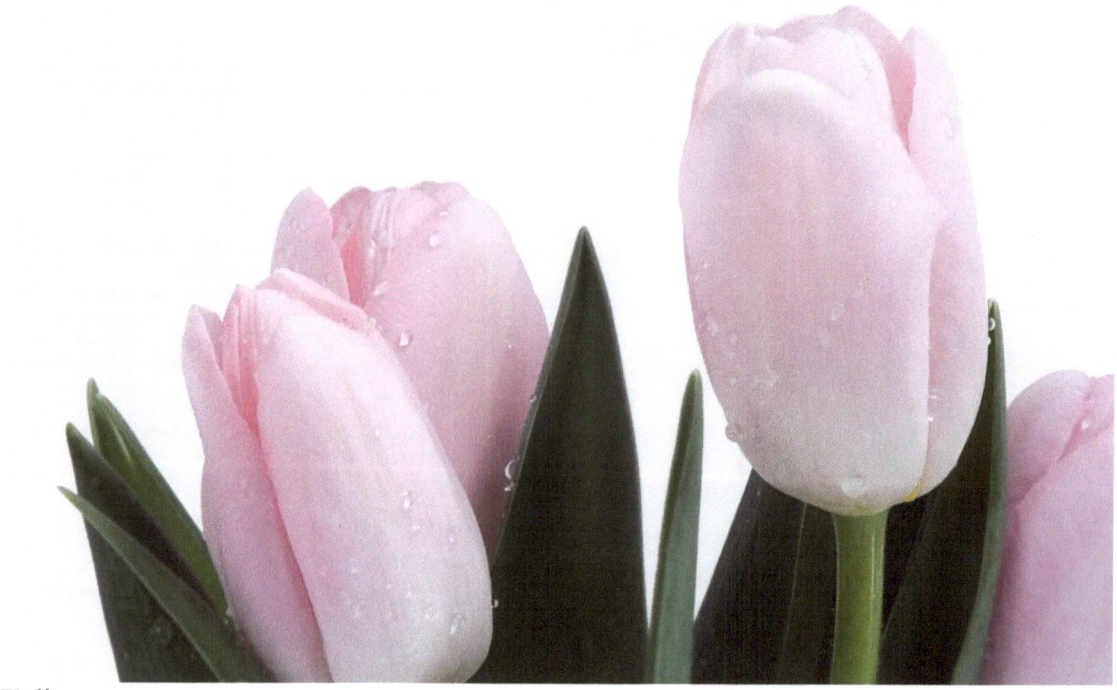

Tulips

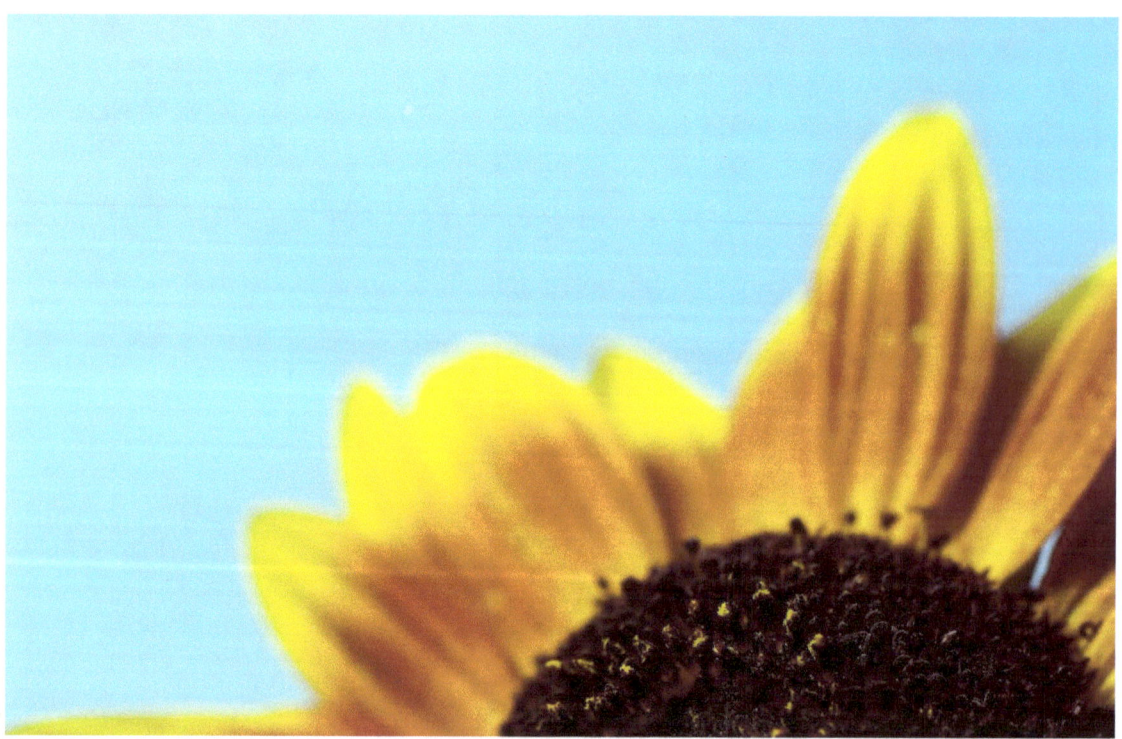

Sunflower

Mother Nature's Best Side A Picture Journey

Winecup

The Wild Lily

Mother Nature's Best Side A Picture Journey

The Mexican Hat Wildflower
Beauty comes in all forms it is our job to recognize that and appreciate what we have.

The Lotus reflecting off the sunlight

Mother Nature's Best Side A Picture Journey

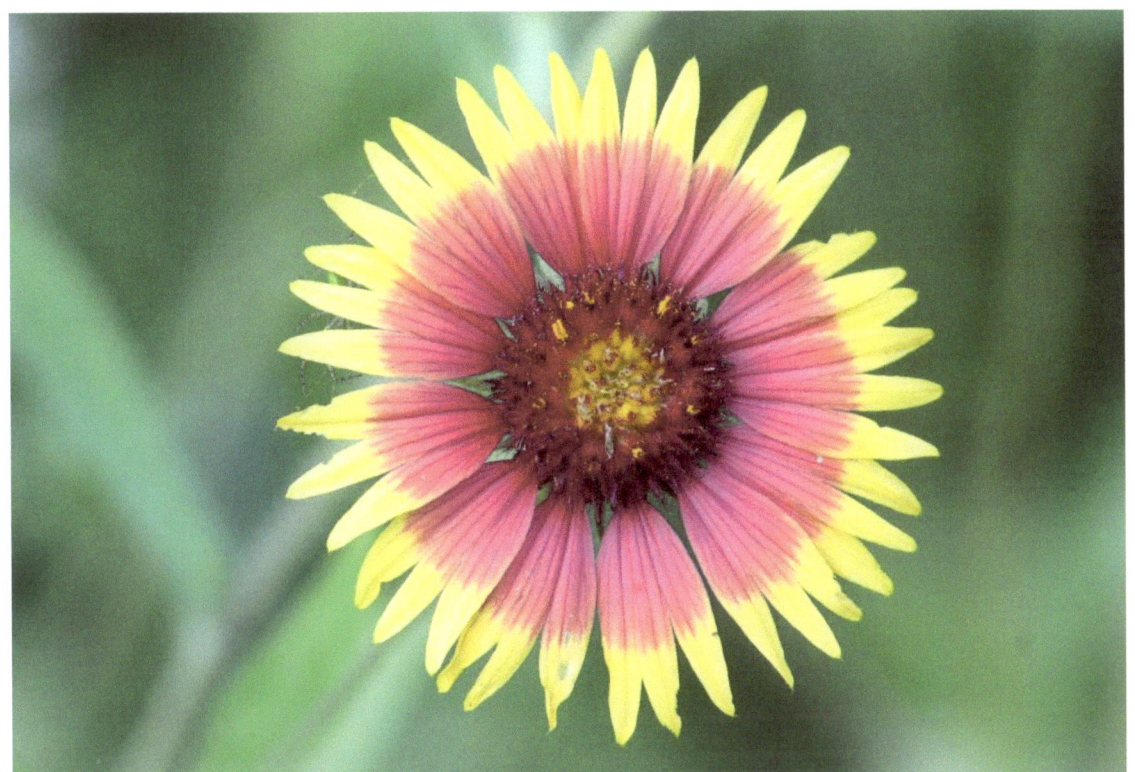

The Firewheel simply stunning

Mother Nature's Version Of Abstract Art

Mother Nature's Best Side A Picture Journey

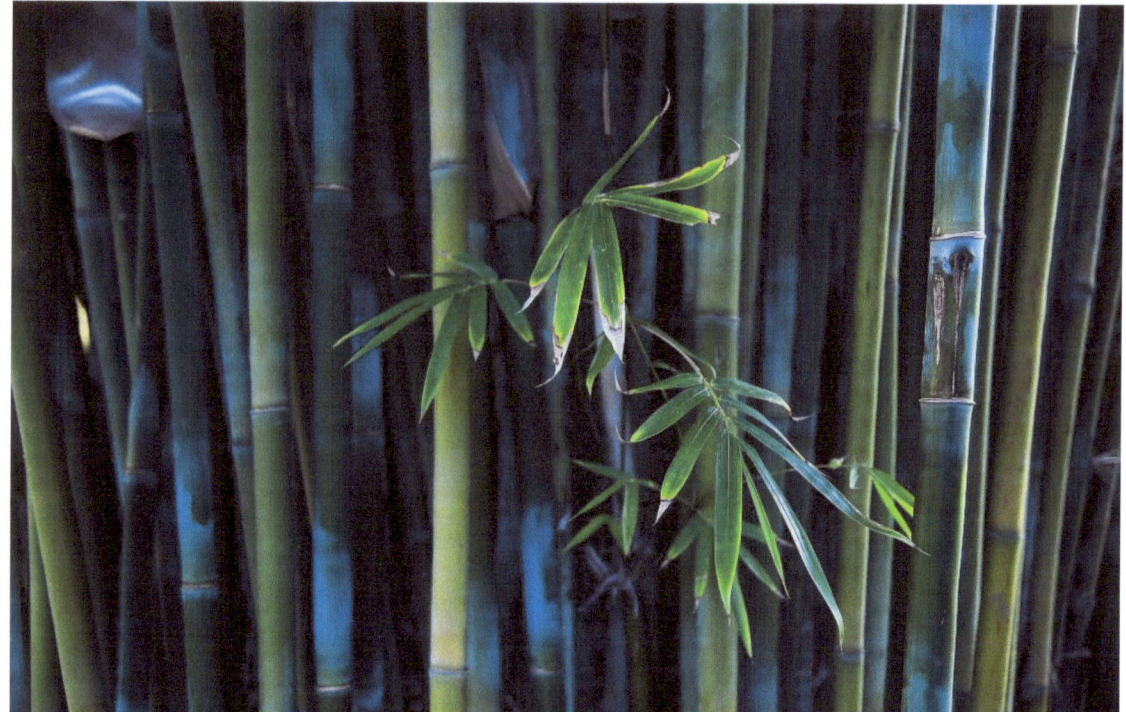

Bamboo Shoots close up

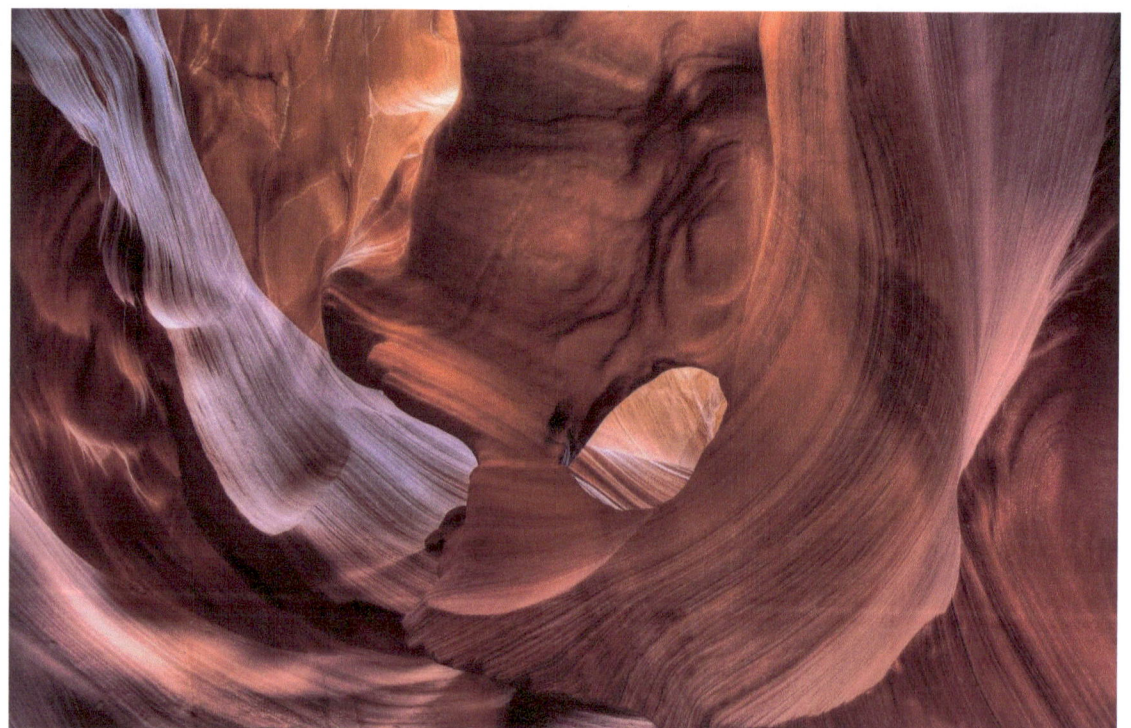

Bryce Canyon in Utah

Mother Nature's Best Side A Picture Journey

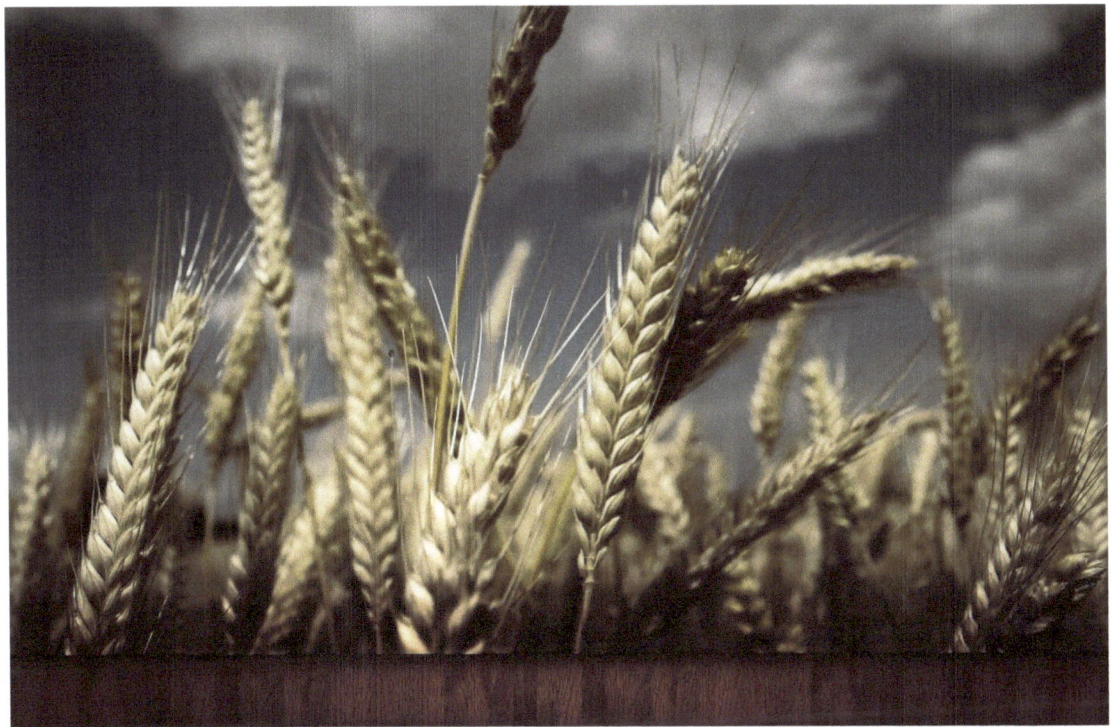

Wheat Stalks Nature's Bounty

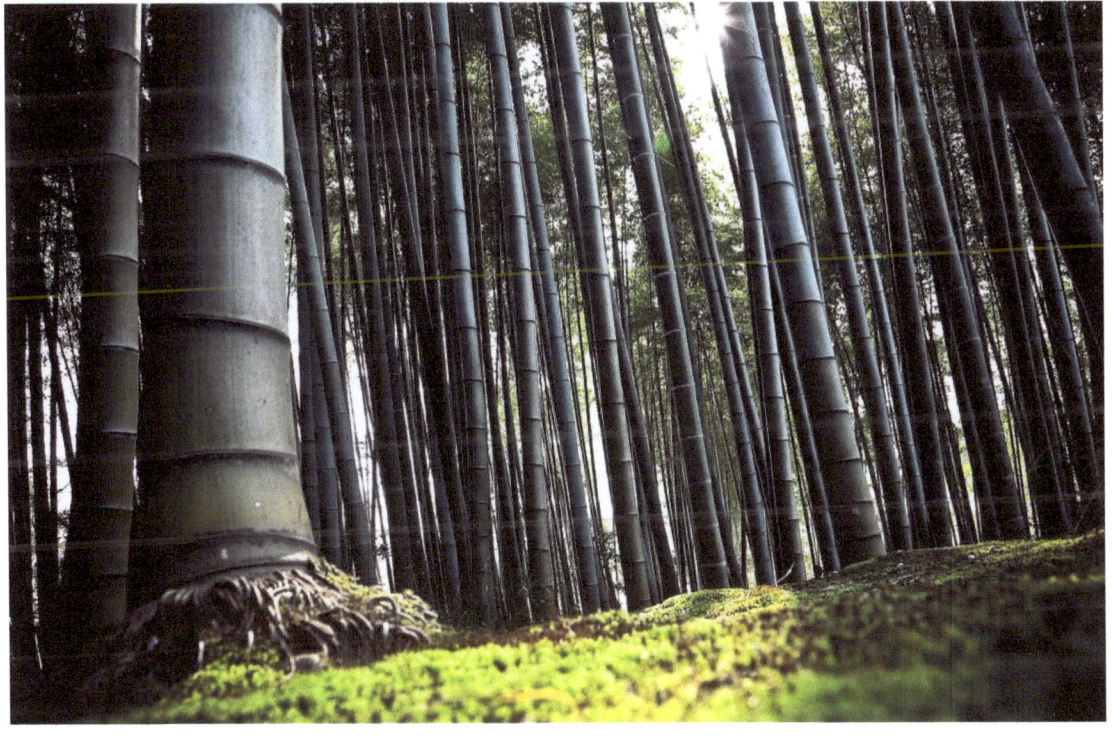

Mother Nature's Best Side A Picture Journey

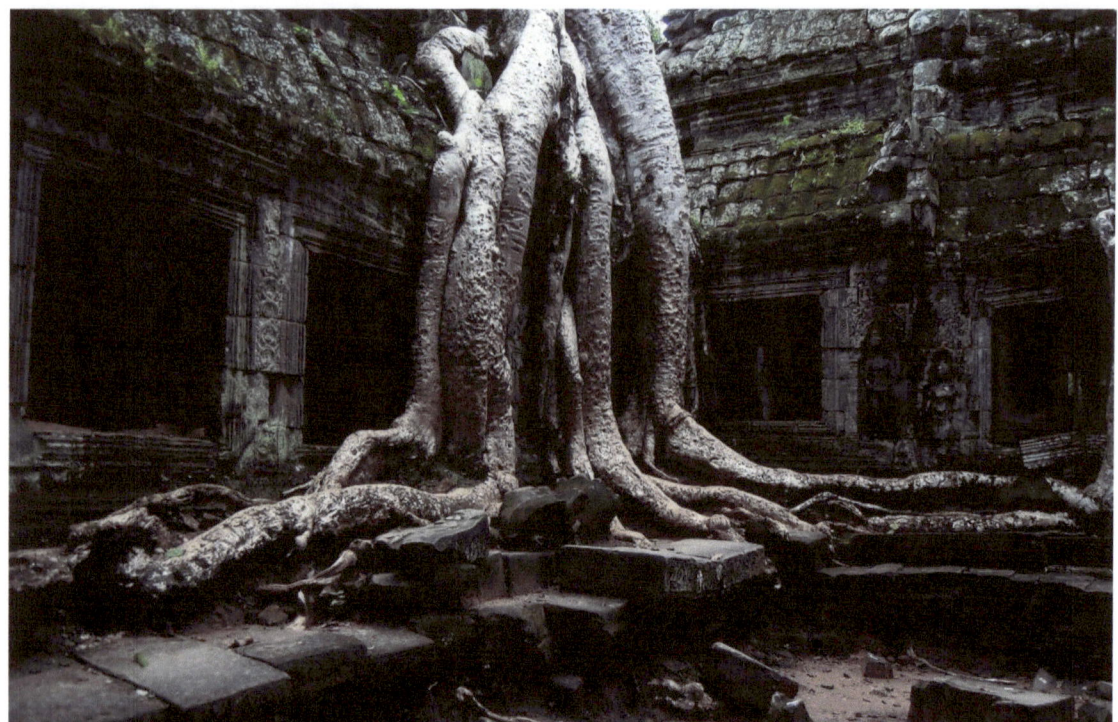

The old guarding the old

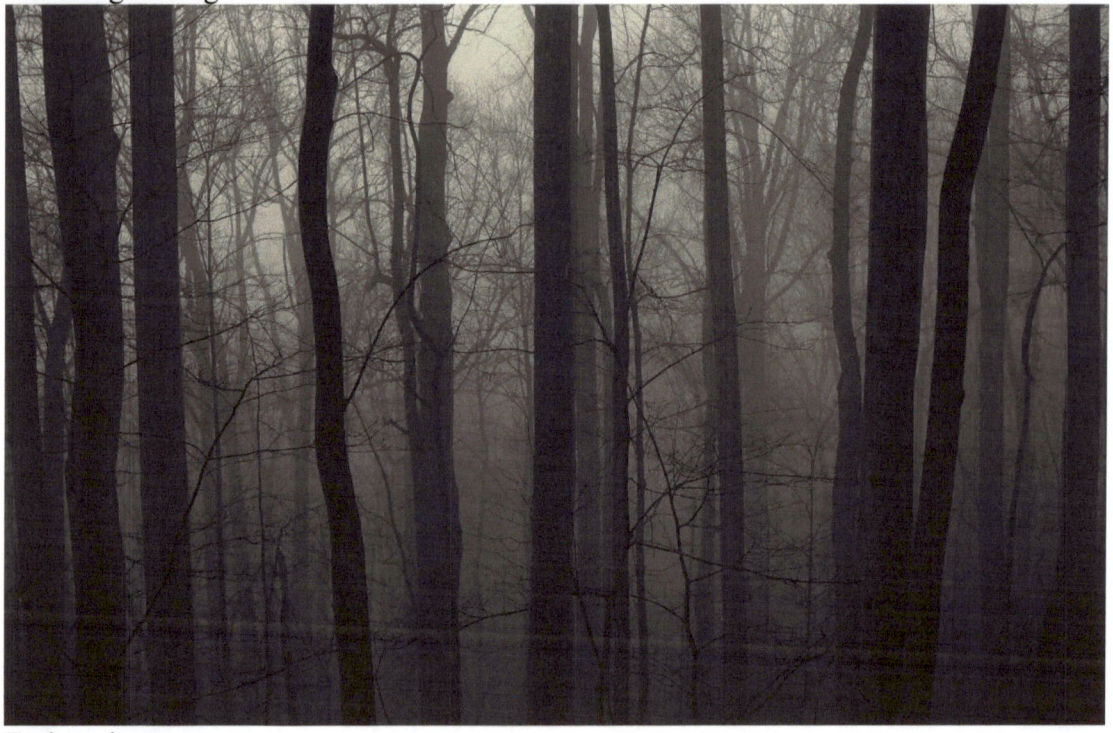

Eerie quite

Mother Nature's Best Side A Picture Journey

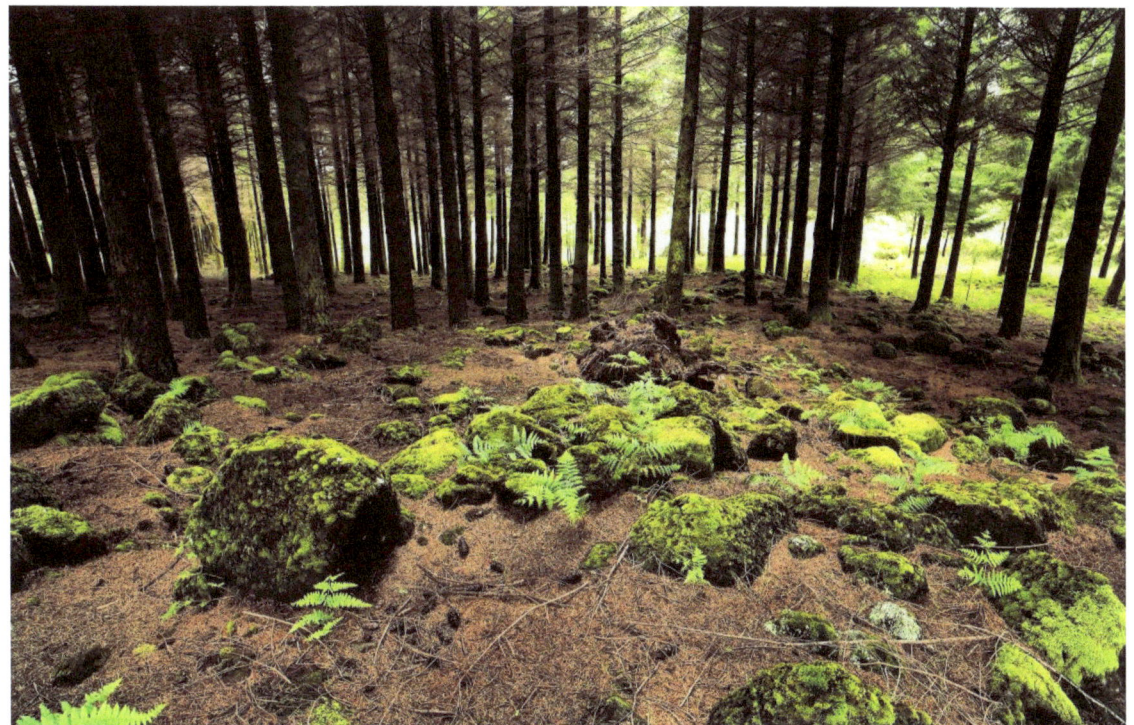

Moss covered rocks in clearing

Ice forming on a river

Mother Nature's Best Side A Picture Journey

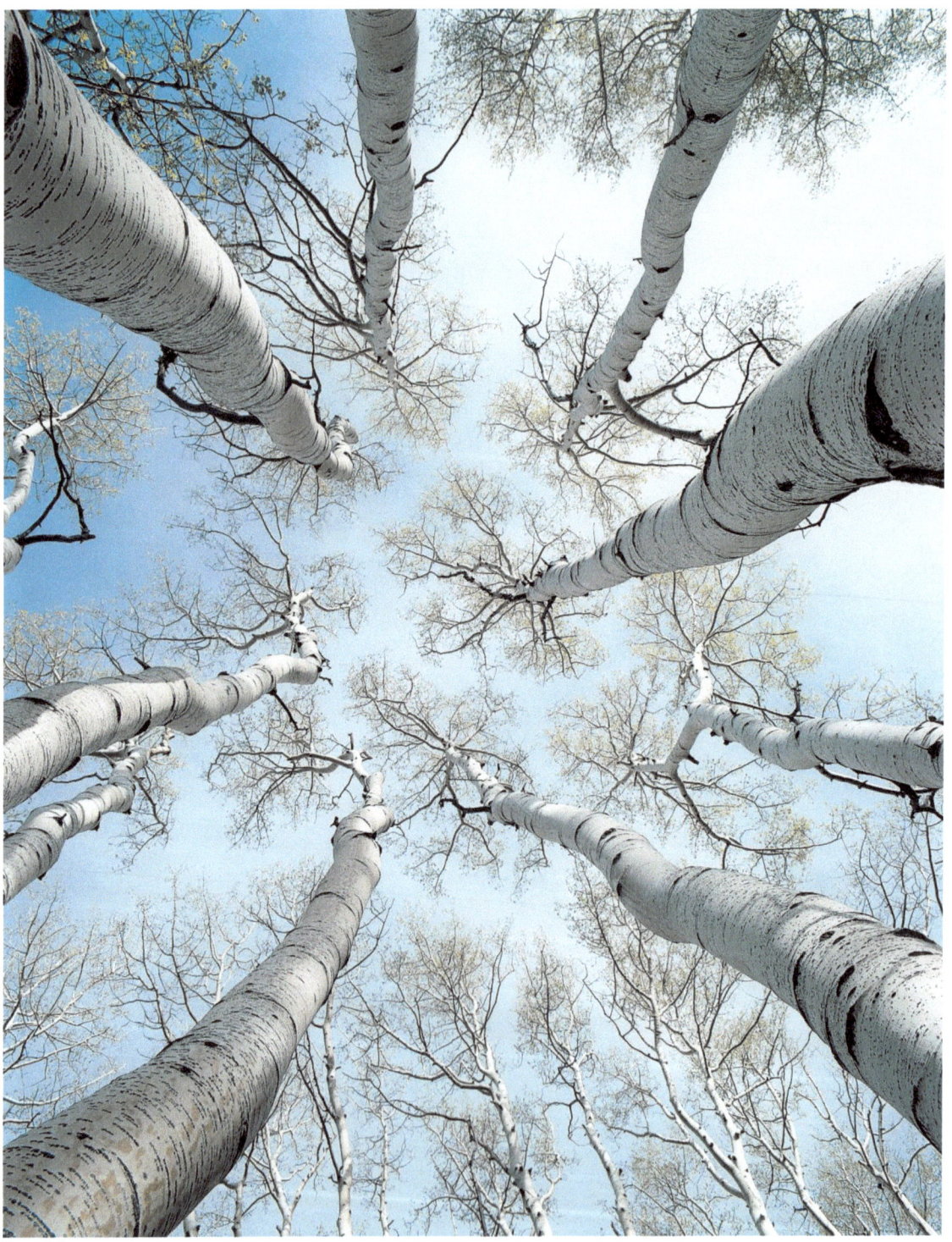

Looking up

Mother Nature's Best Side A Picture Journey

Ice crystals

Ice

Mother Nature's Best Side A Picture Journey

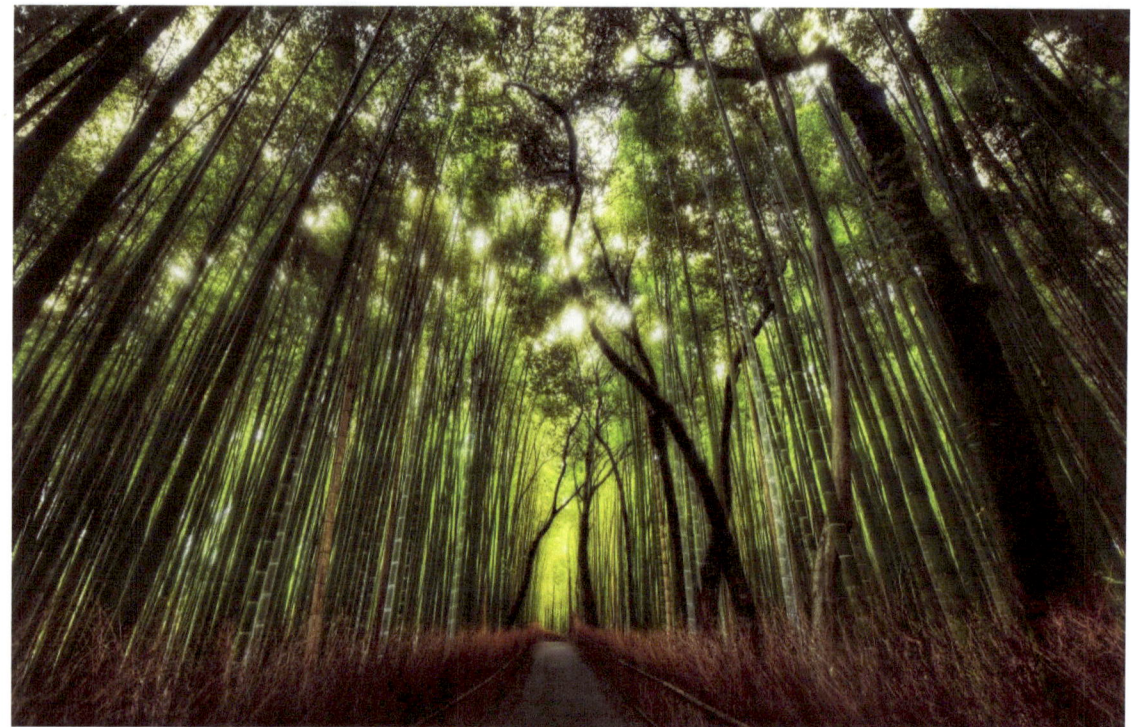

Vertigo

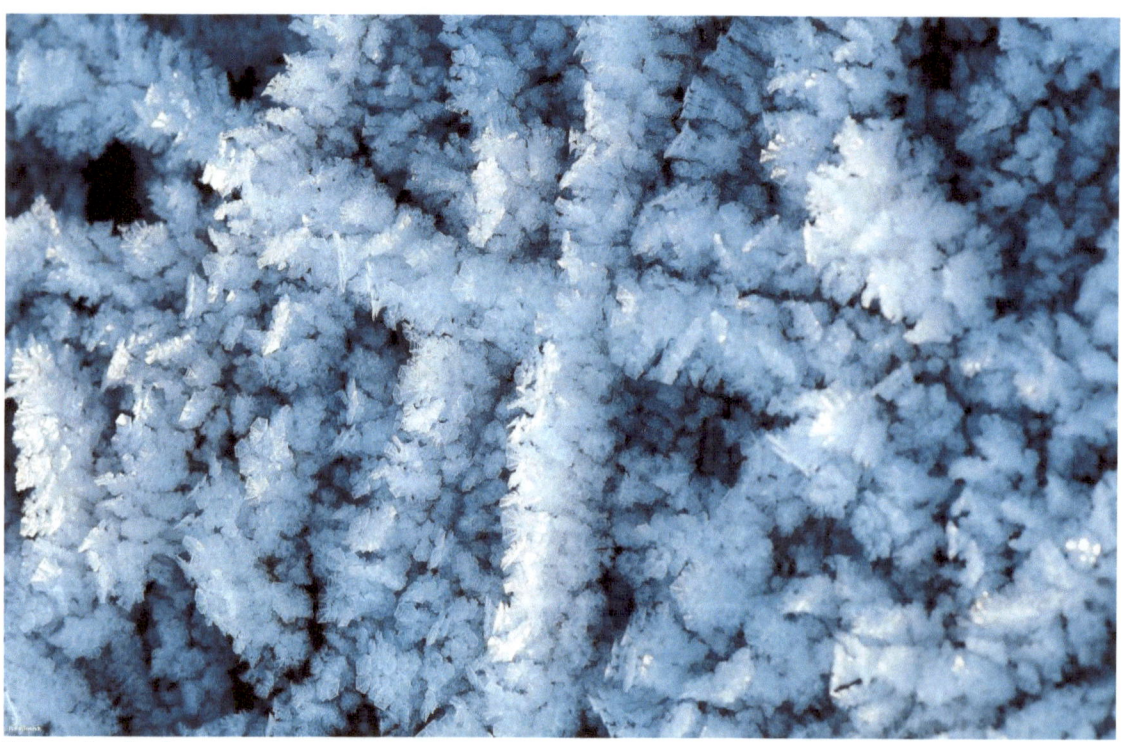

If you look close you can see a cross

Mother Nature's Best Side A Picture Journey

Nature's Reflective Side

Just like us nature has a way of reflecting her beauty for all to see.

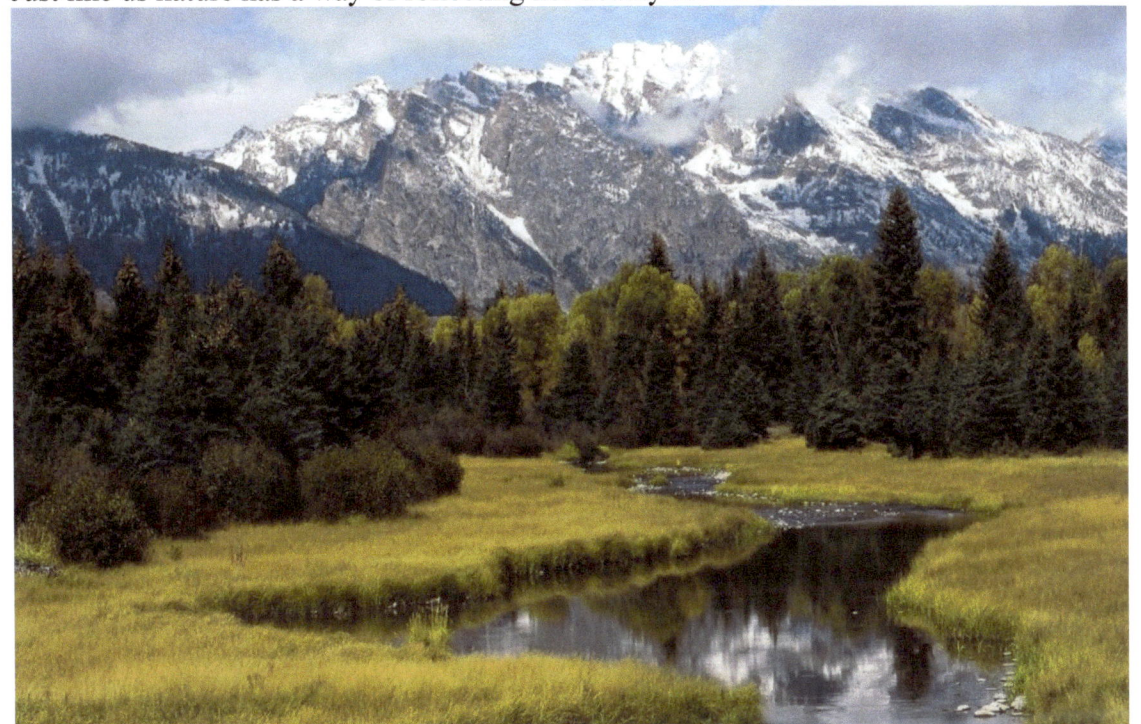

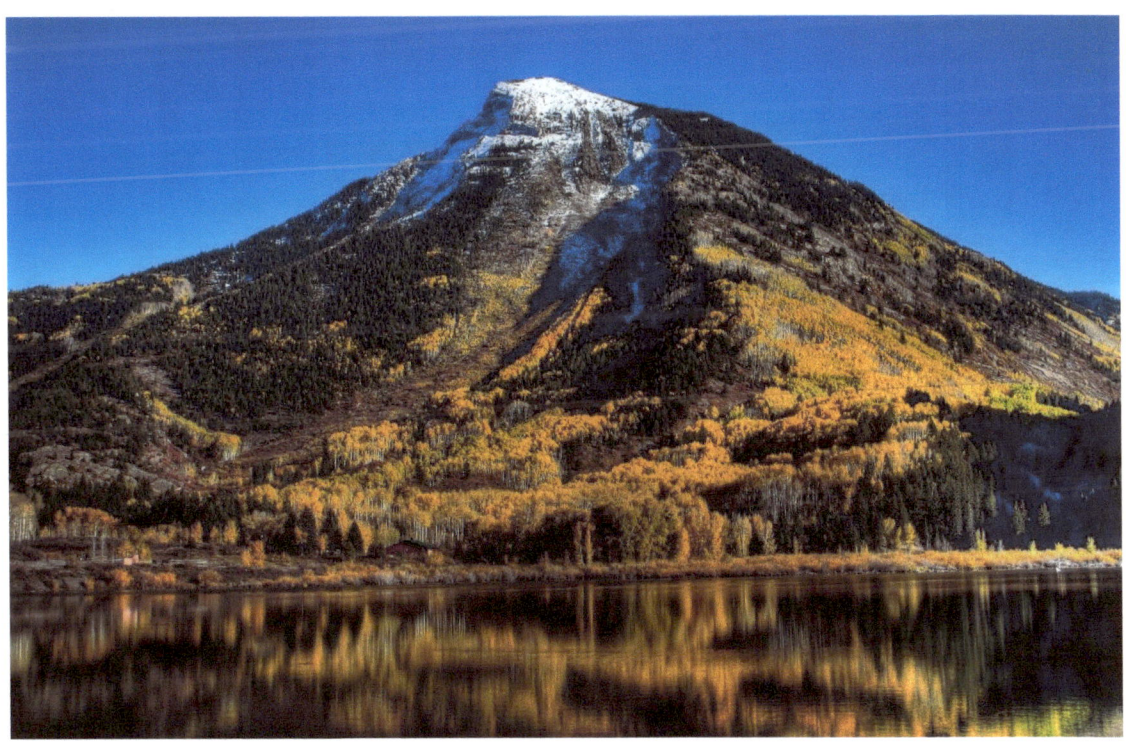

Mother Nature's Best Side A Picture Journey

Mother Nature's Best Side A Picture Journey

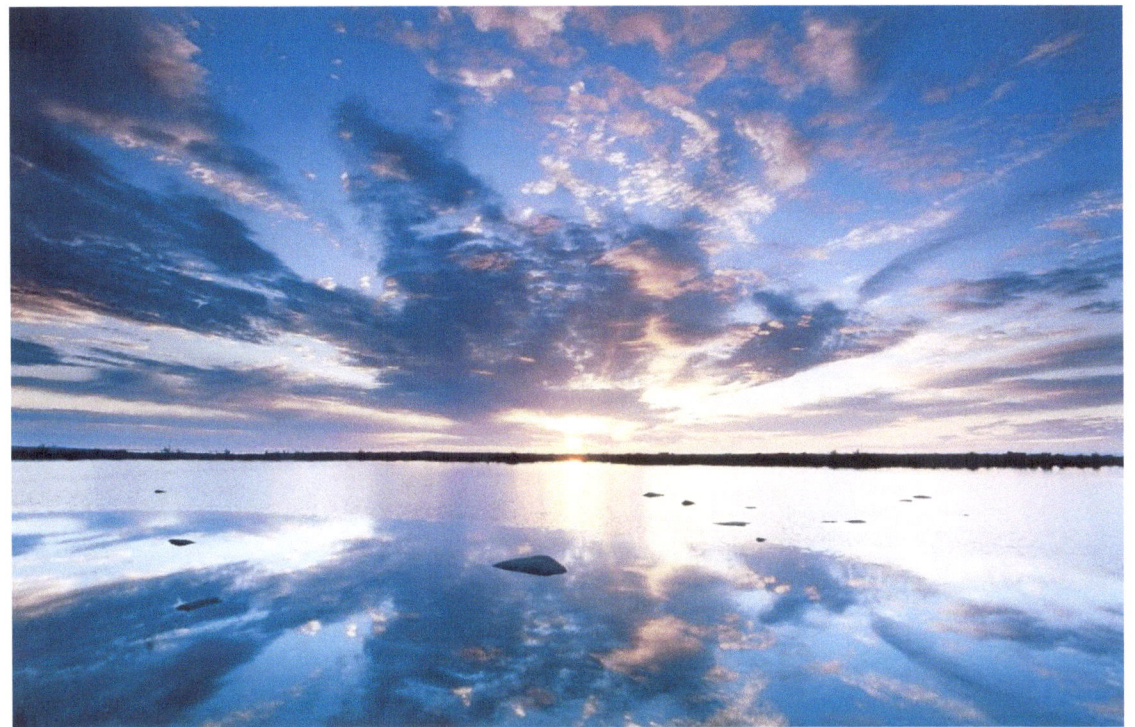

Can't tell if you are looking up or down.

Rivers and Mountains Wild

Mother Nature's Best Side A Picture Journey

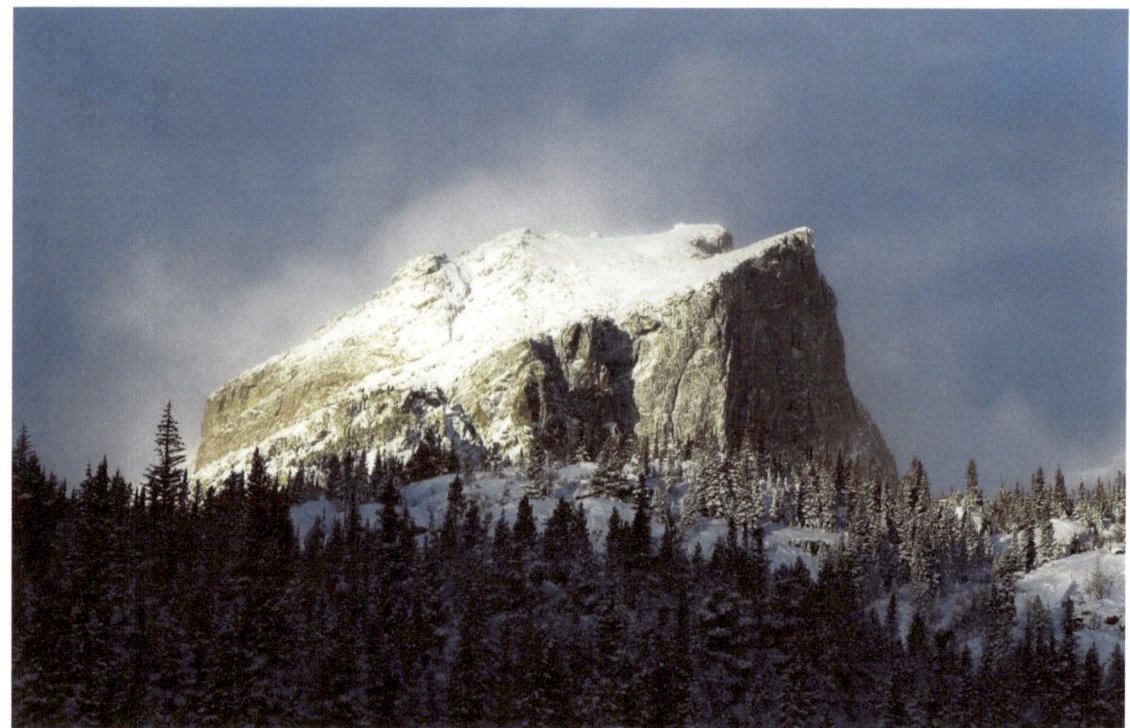

Untamed

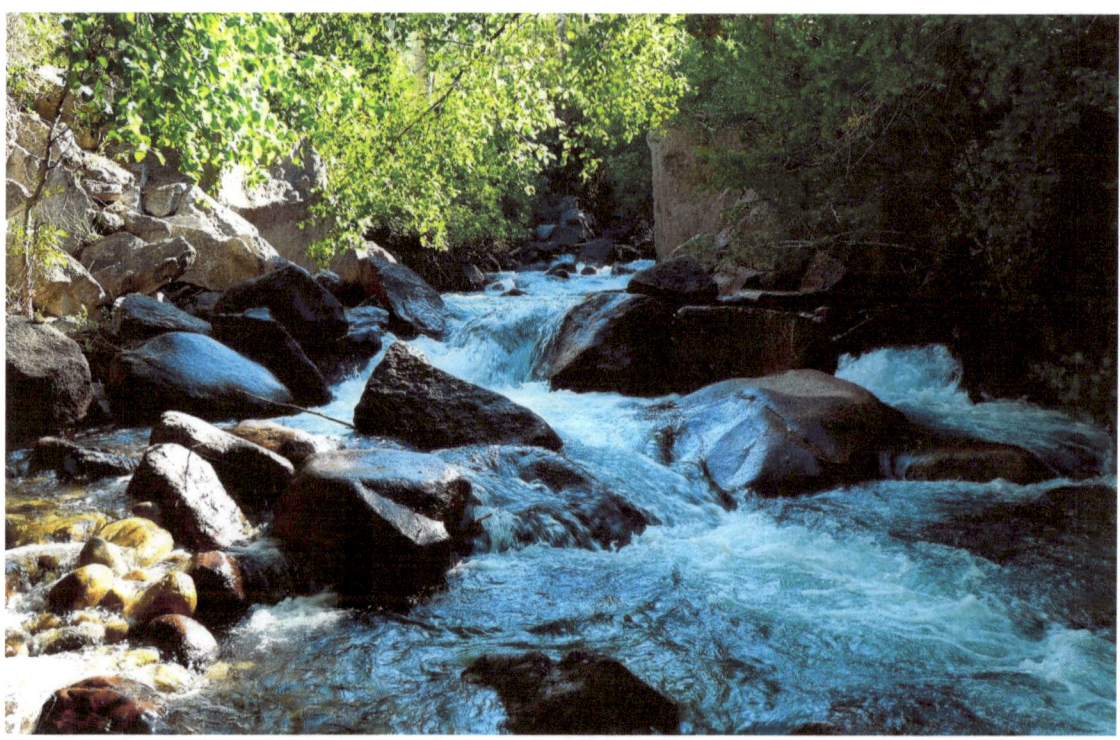

Roaring down through the canyon, listen carefully you can hear nature ROAR!

Mother Nature's Best Side A Picture Journey

Rugged beauty

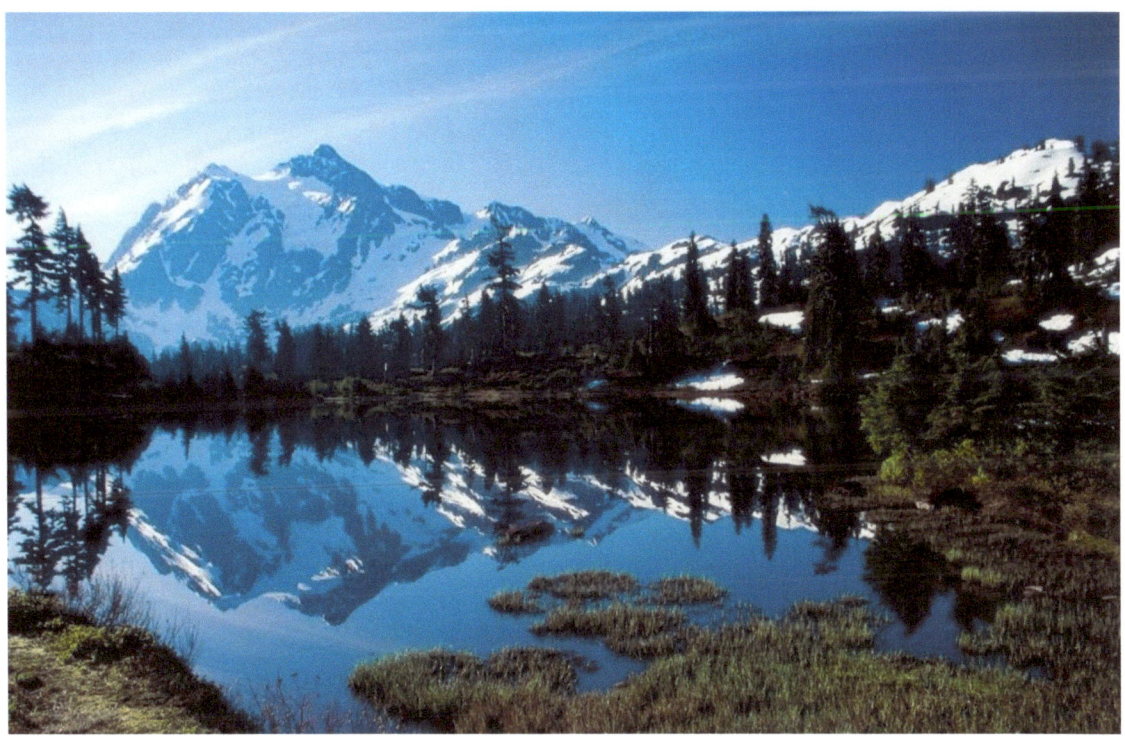

Serenity

Mother Nature's Best Side A Picture Journey

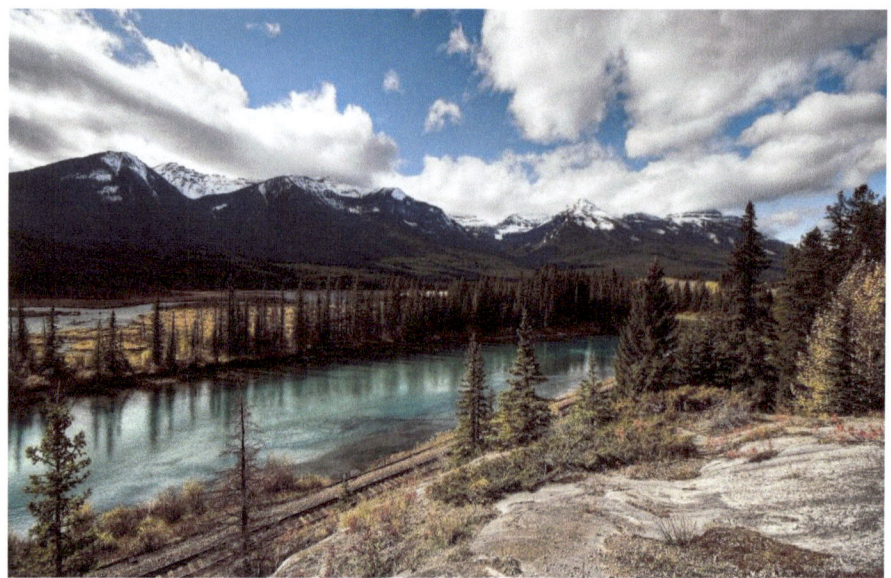

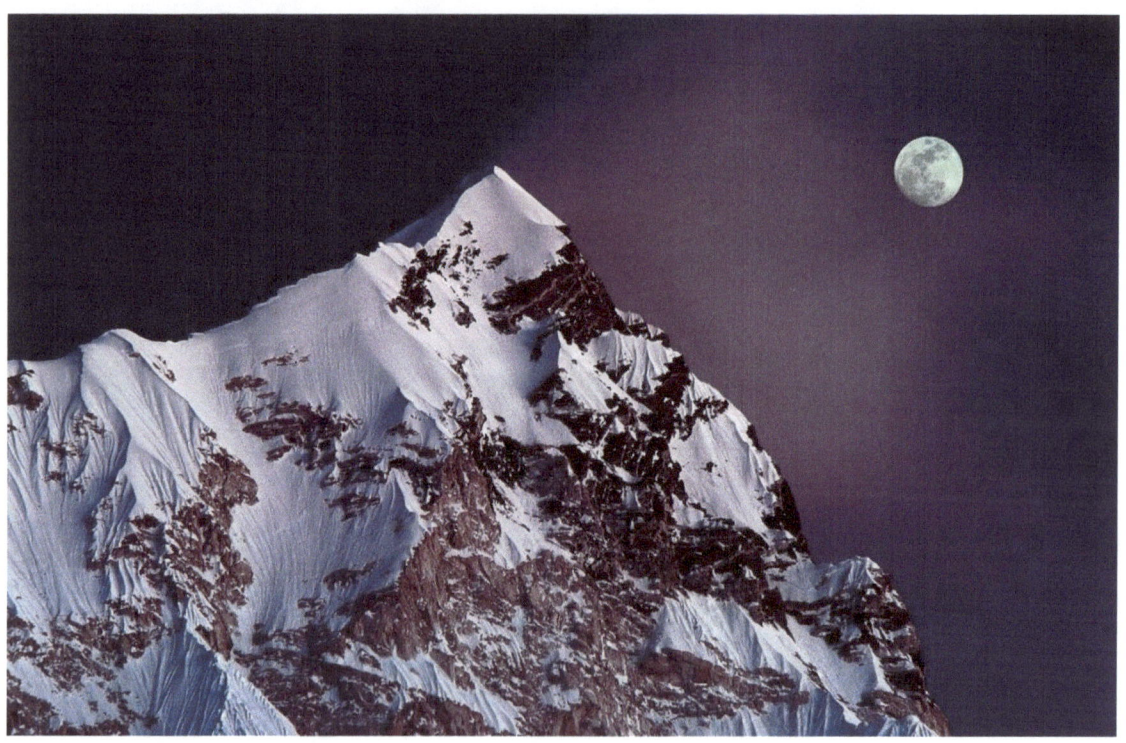

Basking in the moonlight

Mother Nature's Best Side A Picture Journey

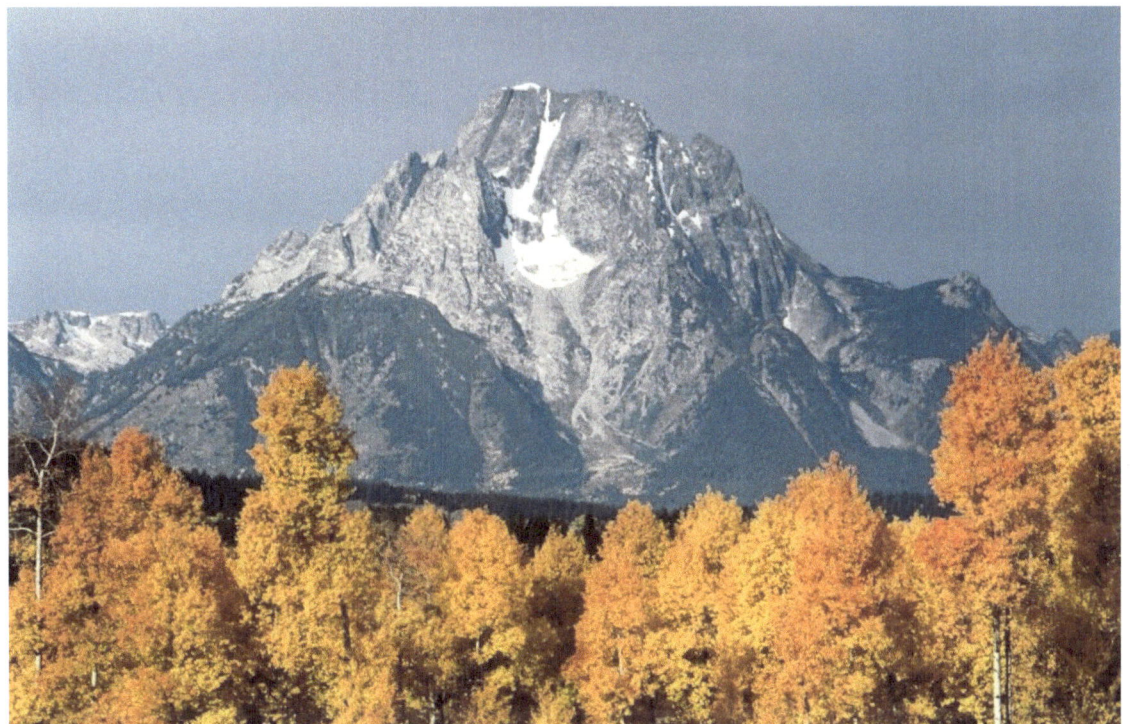

Keeping watch

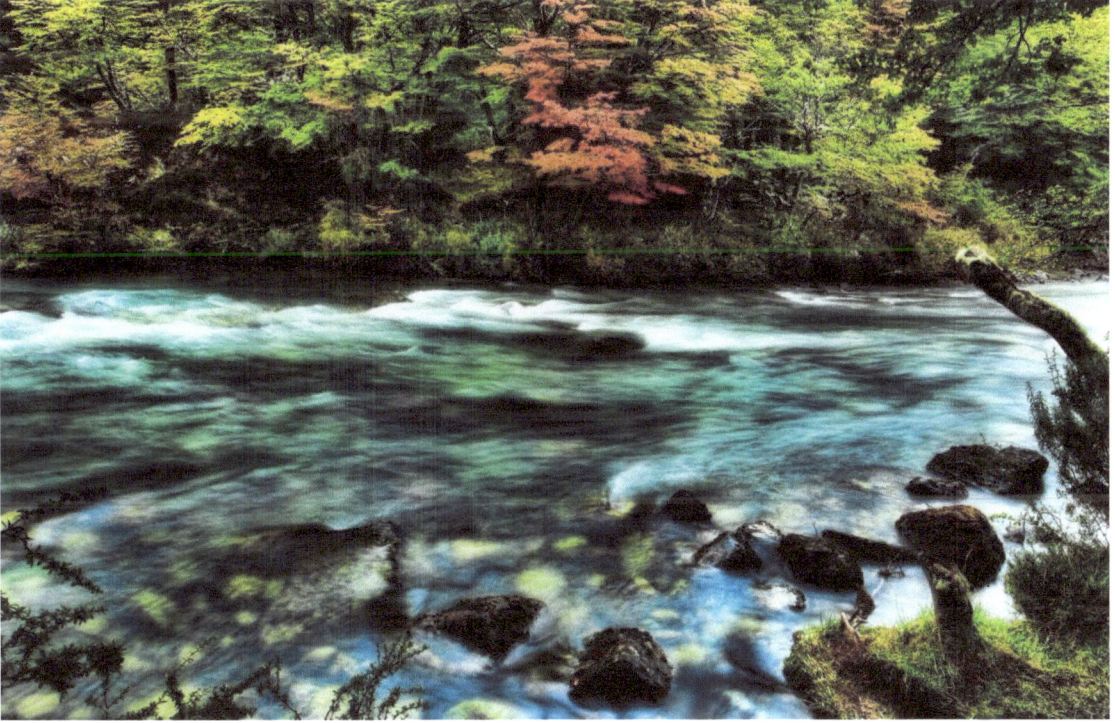

Mother Nature's Best Side A Picture Journey

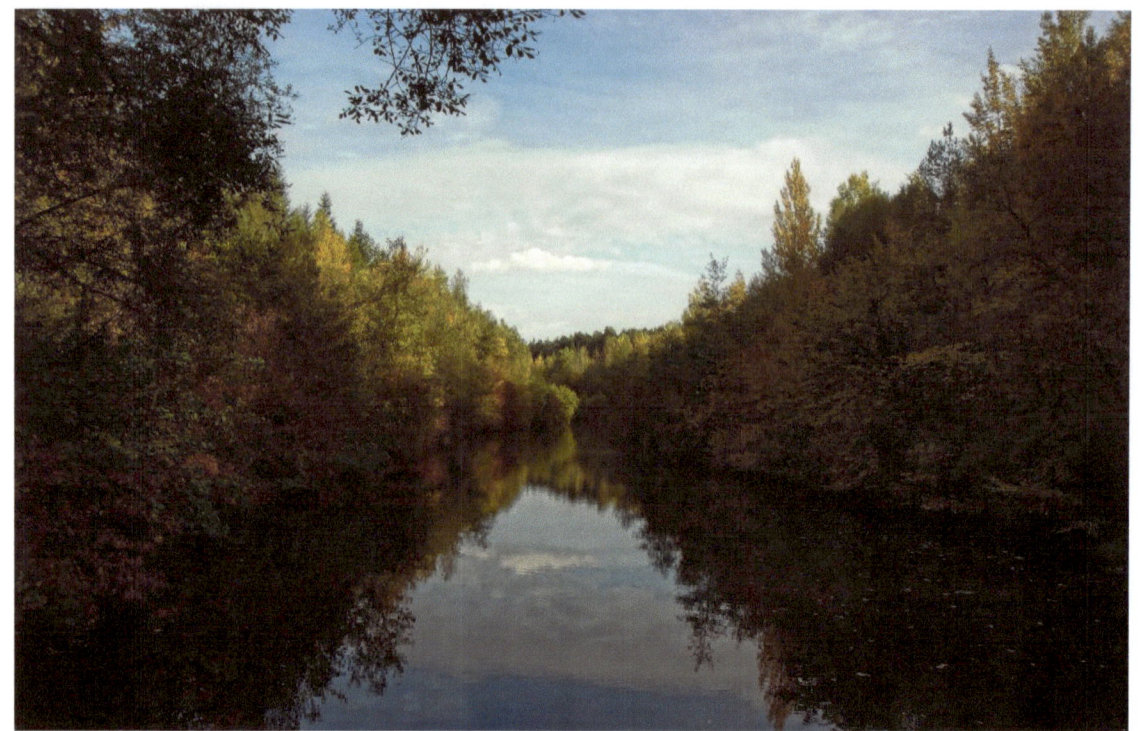

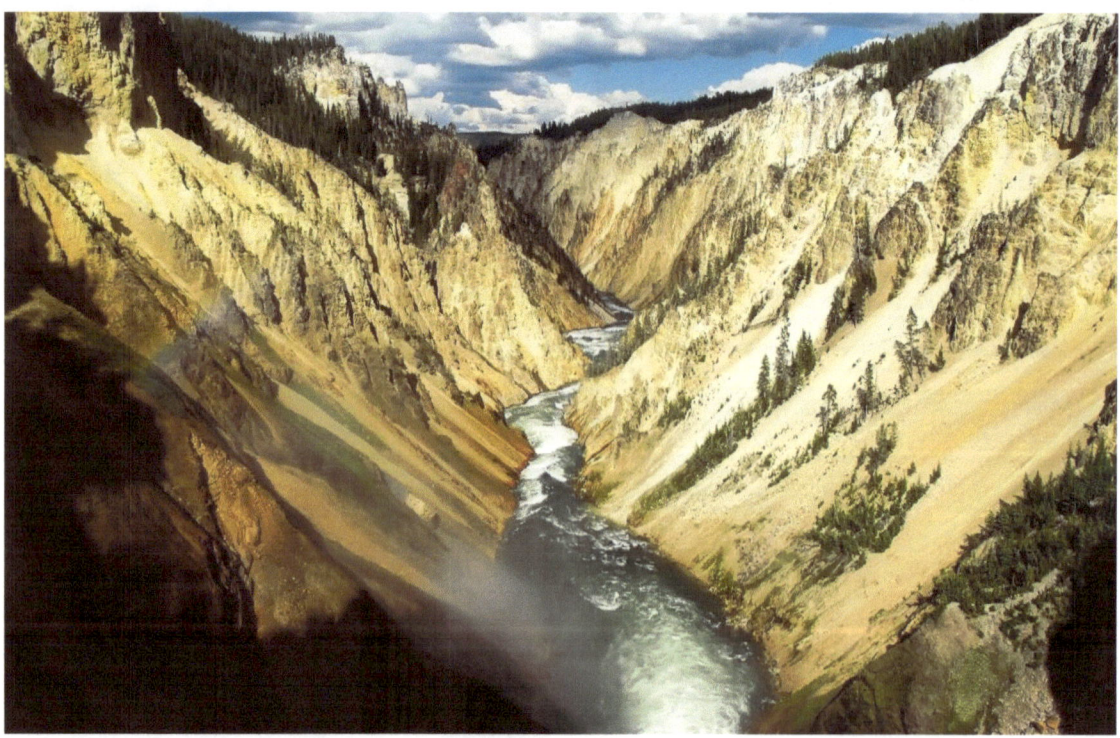

Can you see the faint rainbow from the spray?

Mother Nature's Best Side A Picture Journey

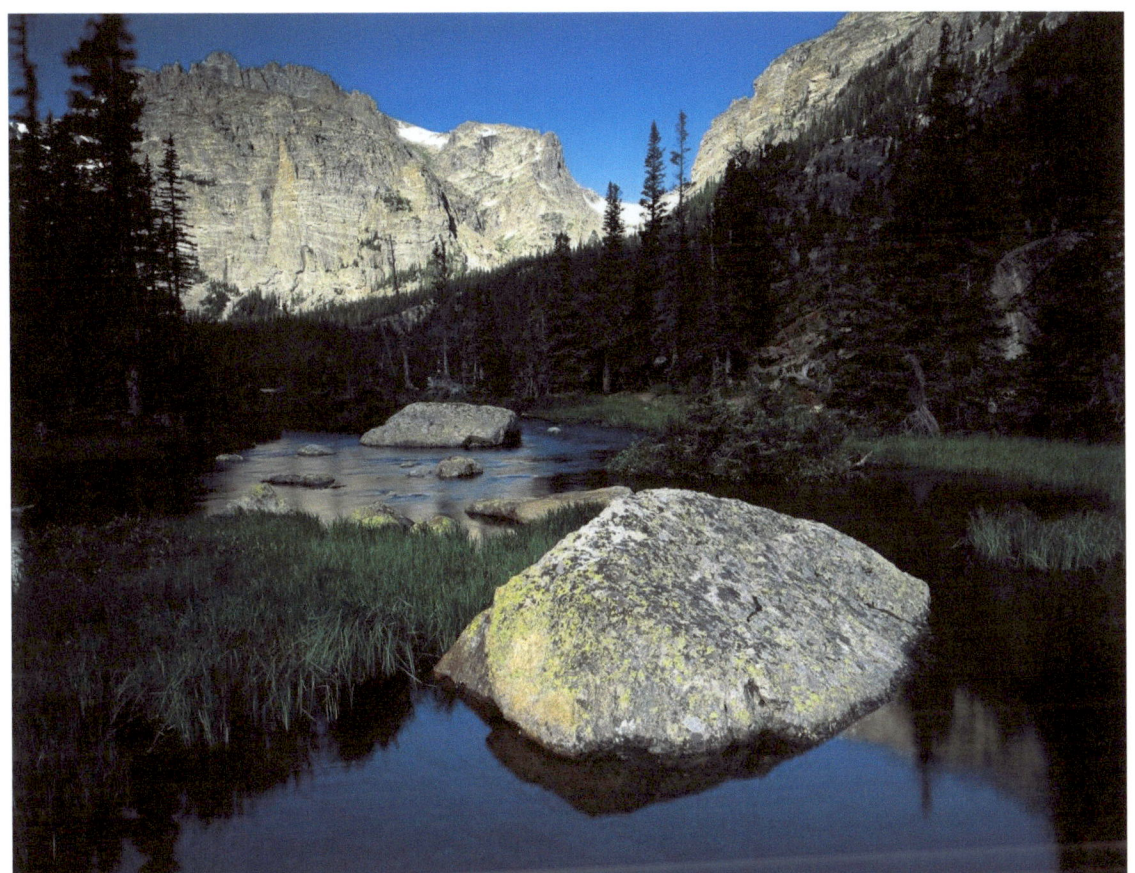

This is my inspiration.

Mother Nature's Best Side A Picture Journey

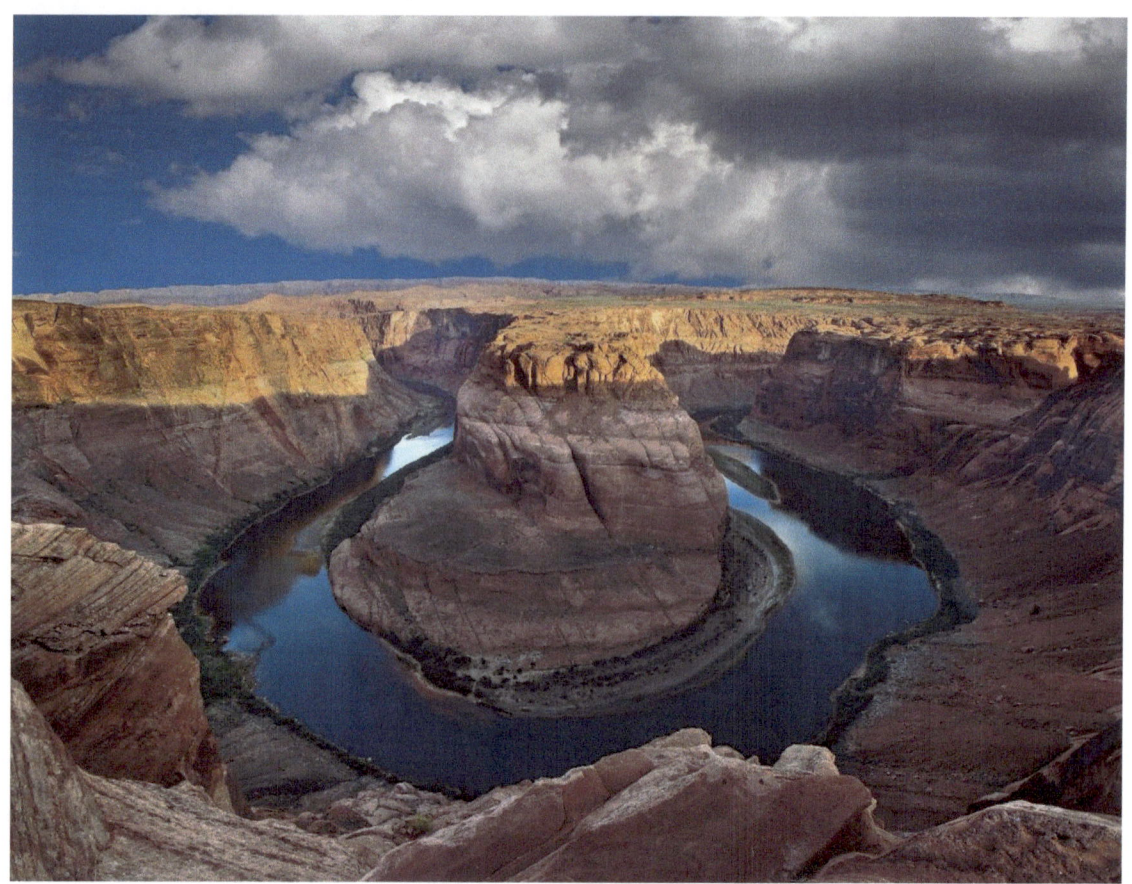

Mother Nature's Best Side A Picture Journey

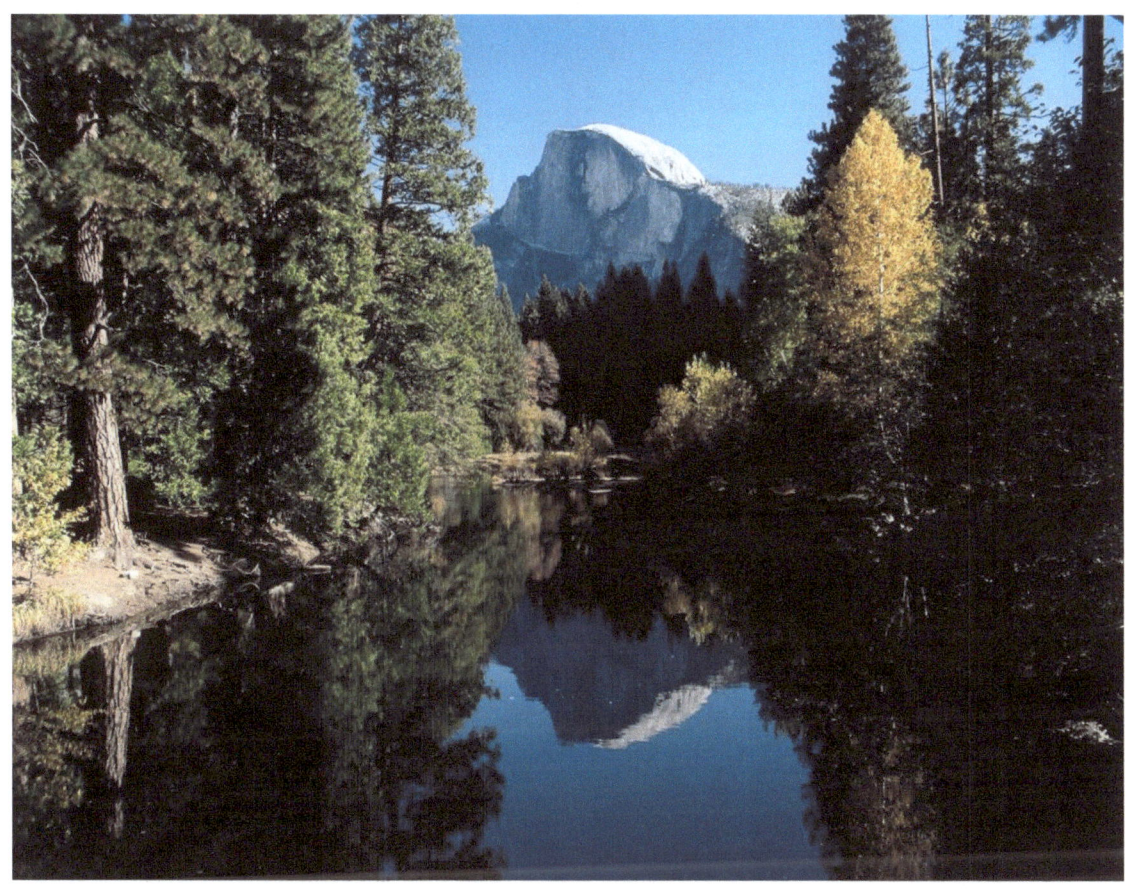

Waterfalls Mother Nature's Drinking Fountain

Mother Nature's Best Side A Picture Journey

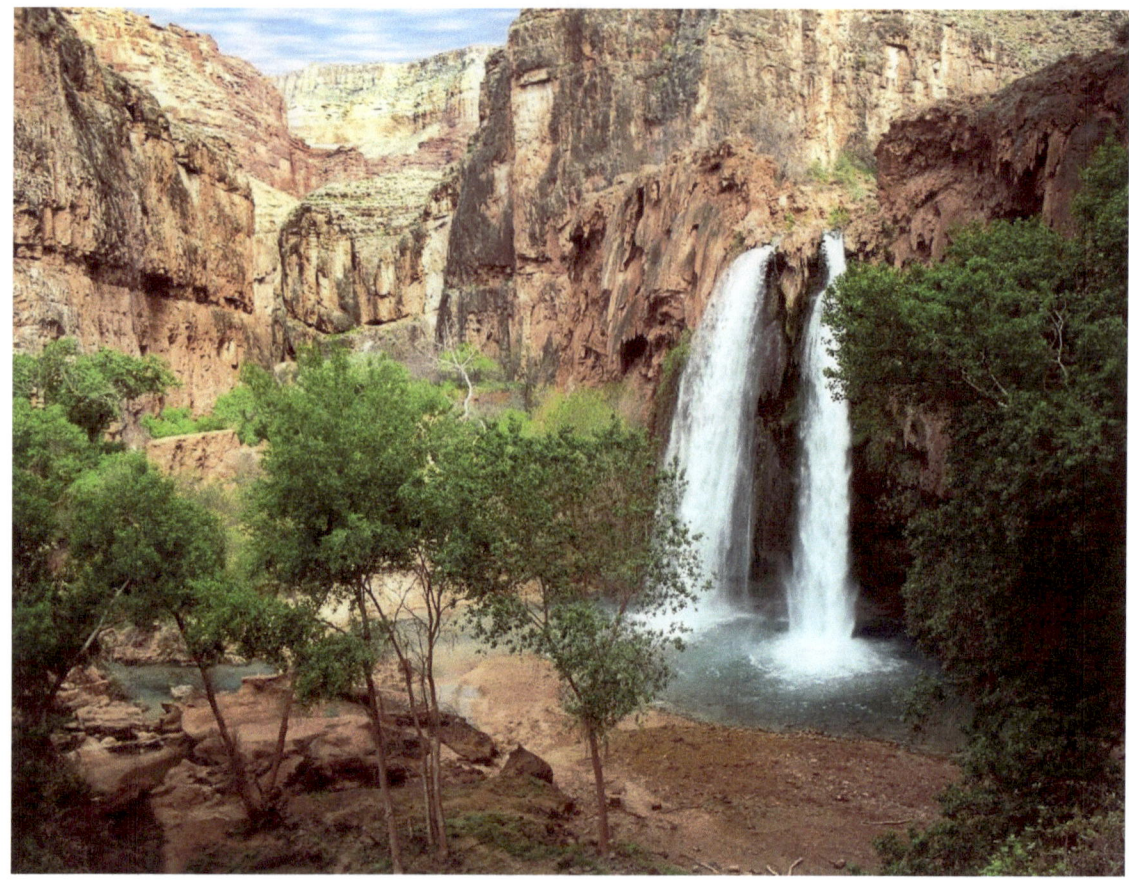

Waterfalls may form where the river flows over a band of hard rock, such as a volcanic sill. The river erodes the soft rock below but it has little effect on the hard band.

Mother Nature's Best Side A Picture Journey

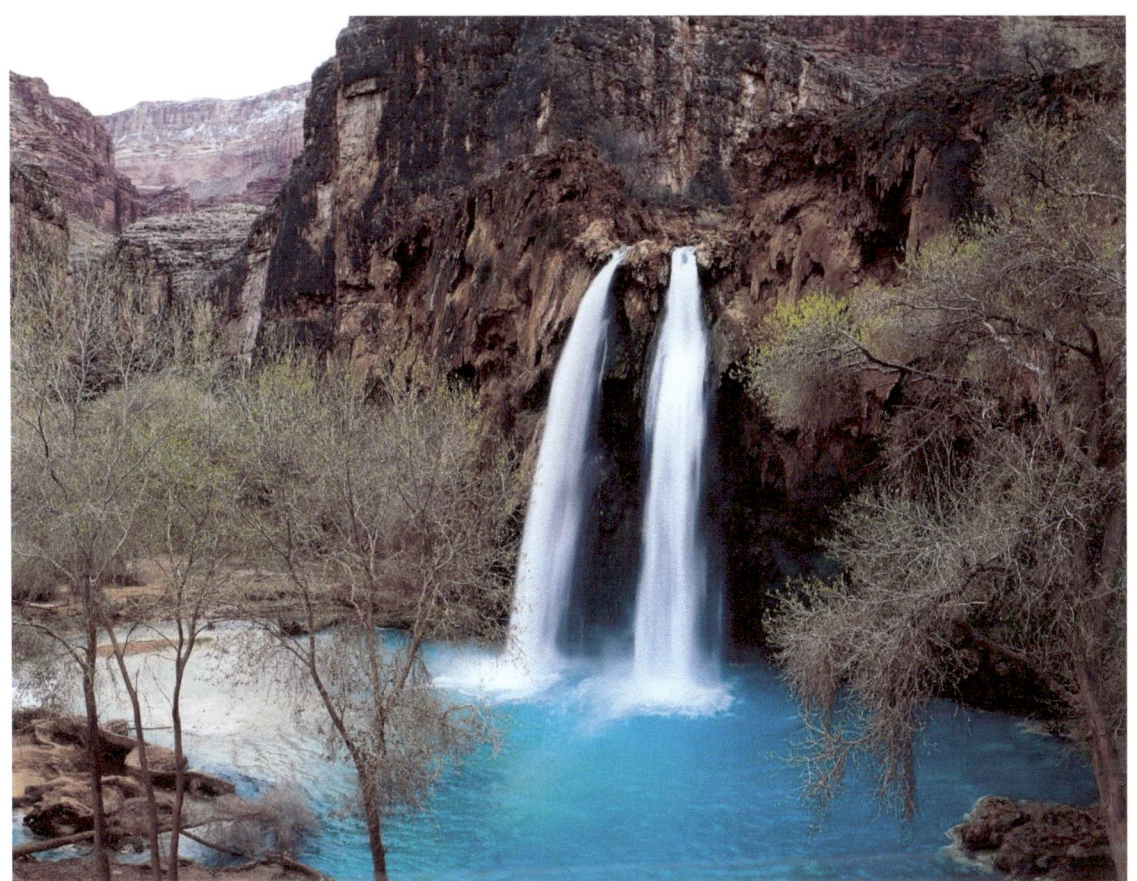

You can find waterfalls in almost every state including Florida!

Mother Nature's Best Side A Picture Journey

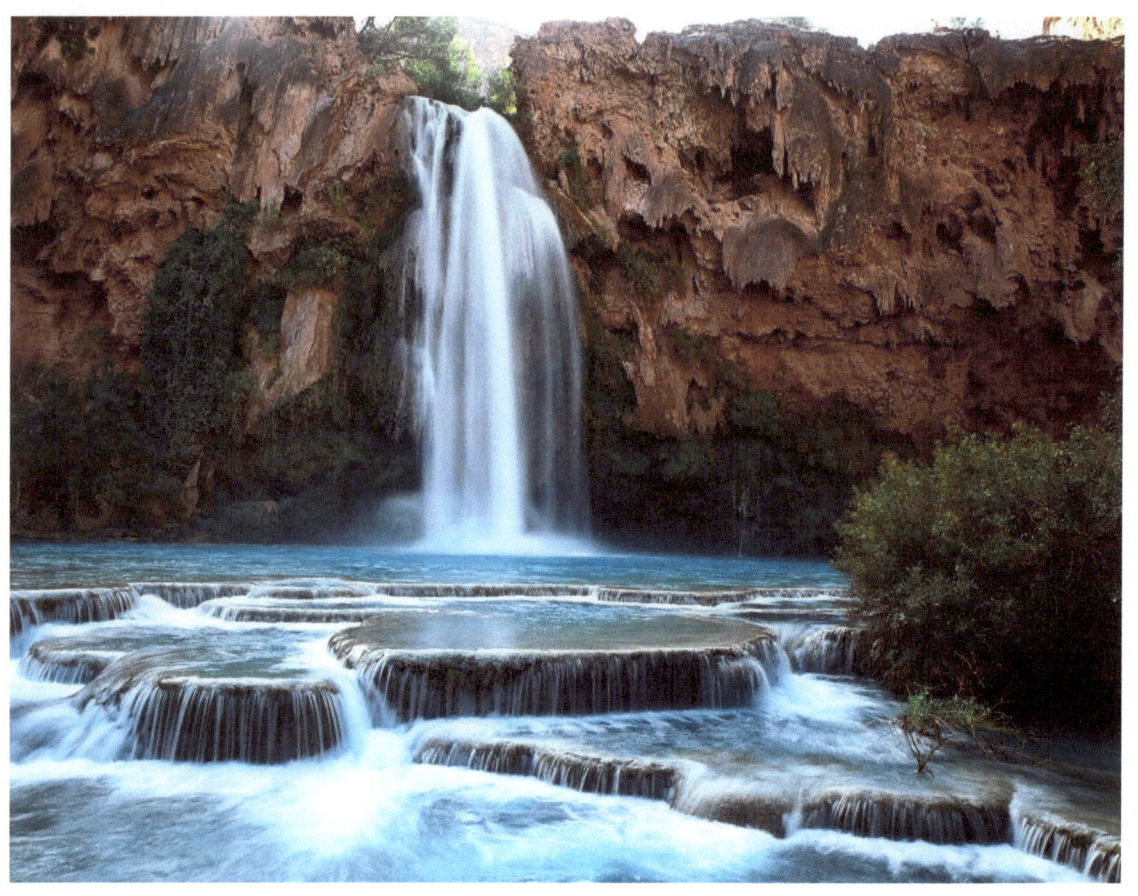

Mother Nature's Best Side A Picture Journey

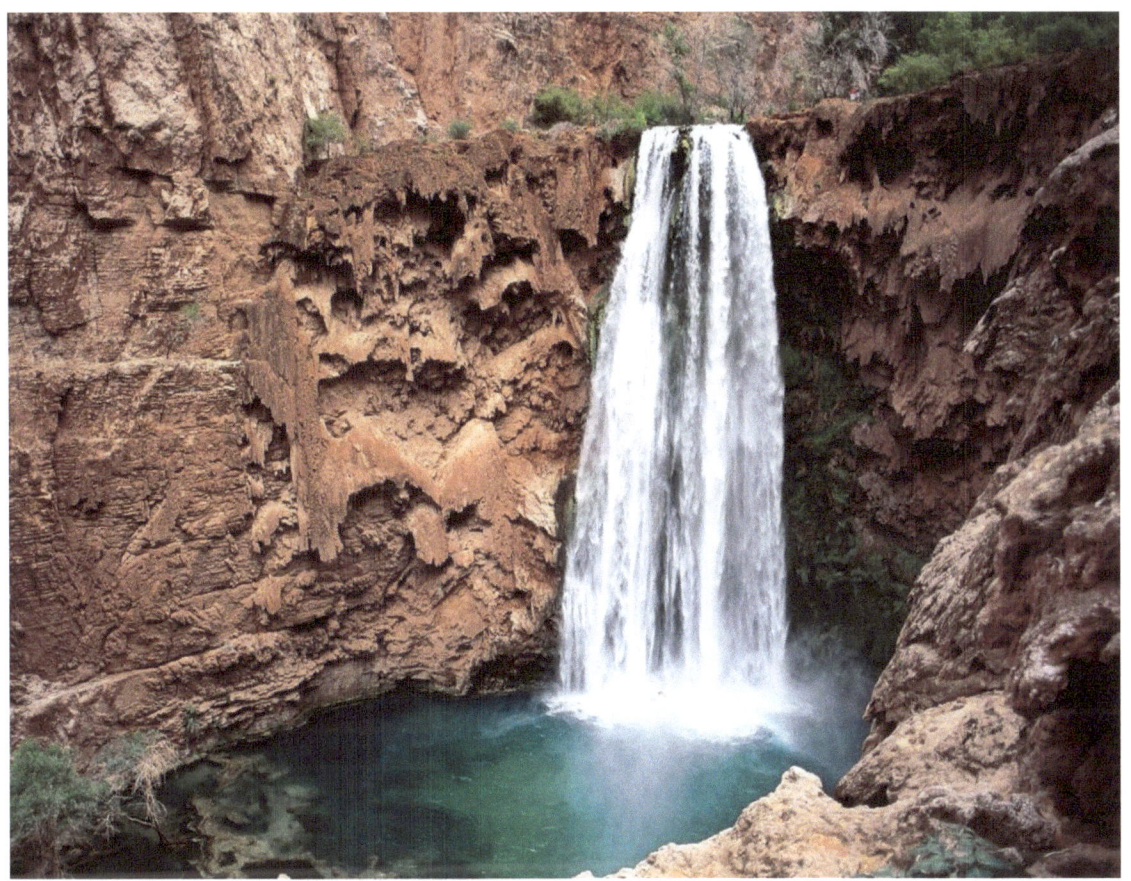

Mother Nature's Best Side A Picture Journey

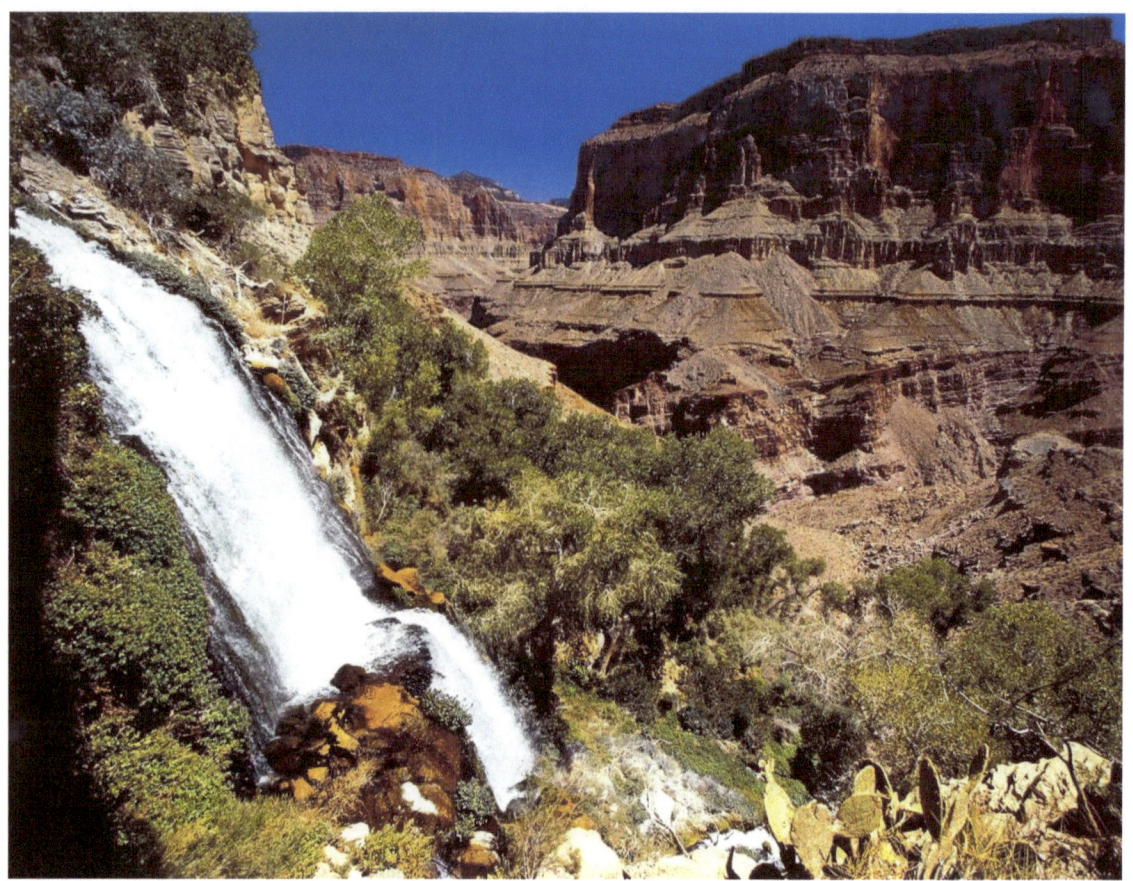

Mother Nature's Best Side A Picture Journey

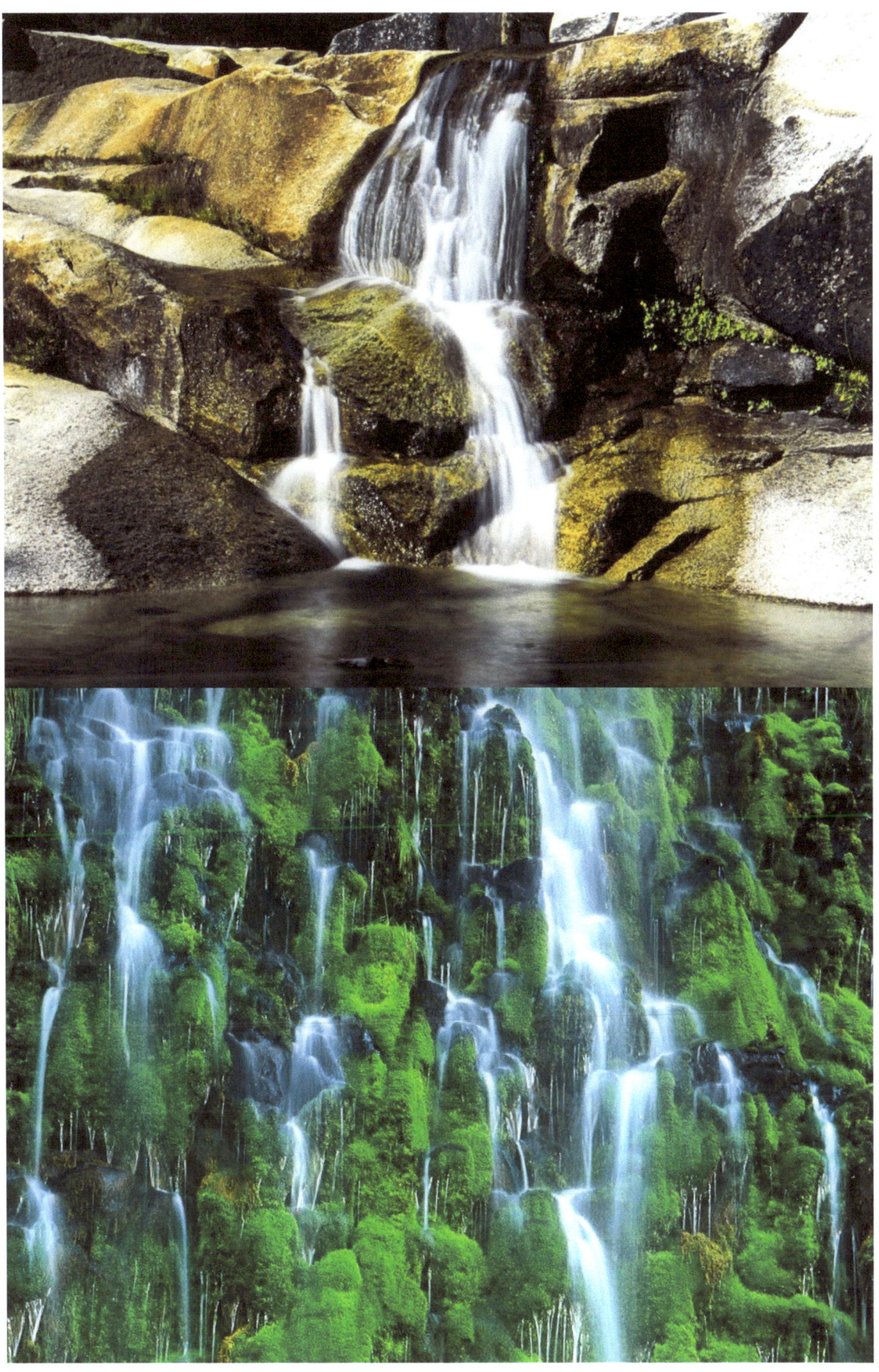

Mother Nature's Best Side A Picture Journey

Conclusion

Next time you are out and about be sure to look for Mother Nature's wonder and beauty it is all around for us to enjoy. I hope you enjoyed this journey around some of the more rugged places in America with me. As I have enjoyed the journey with you.

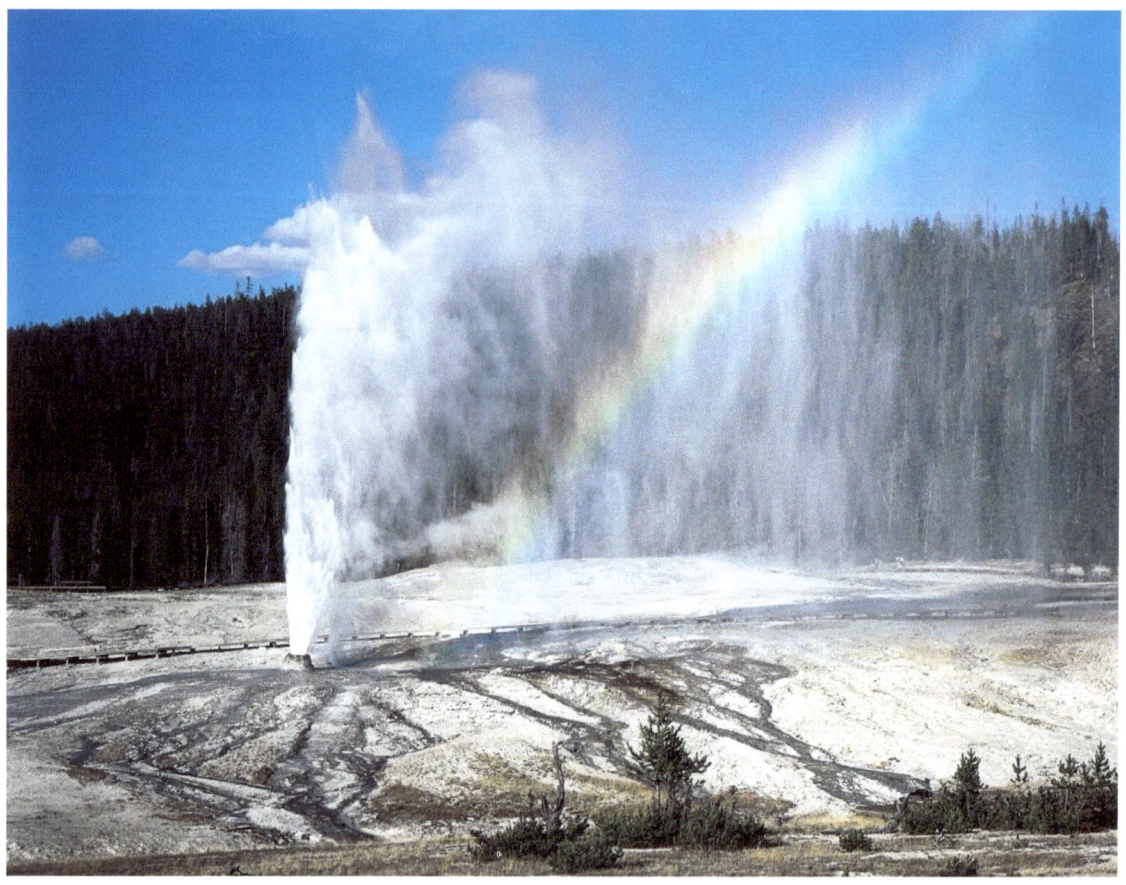

Mother Nature's Best Side A Picture Journey

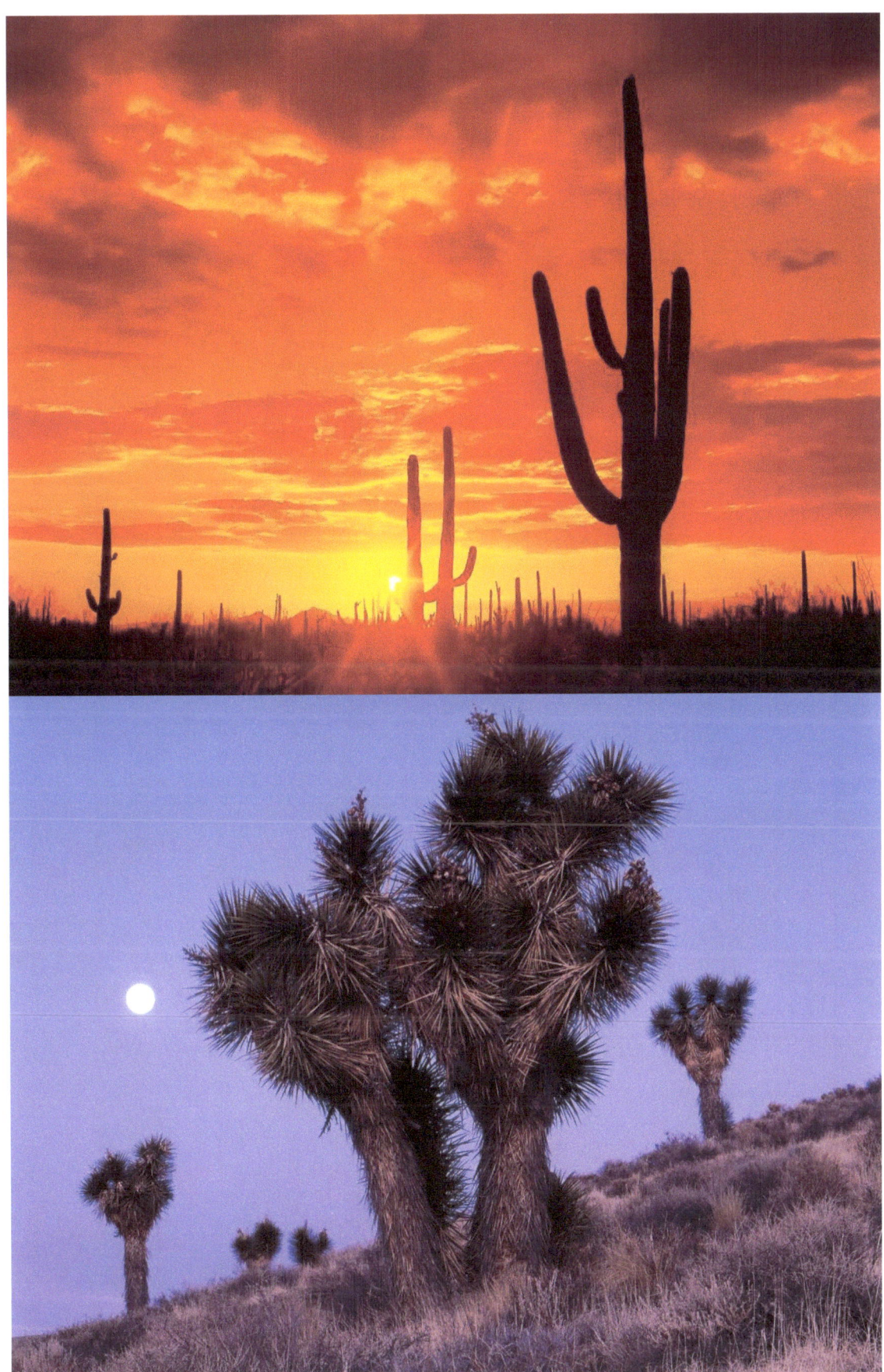

Mother Nature's Best Side A Picture Journey

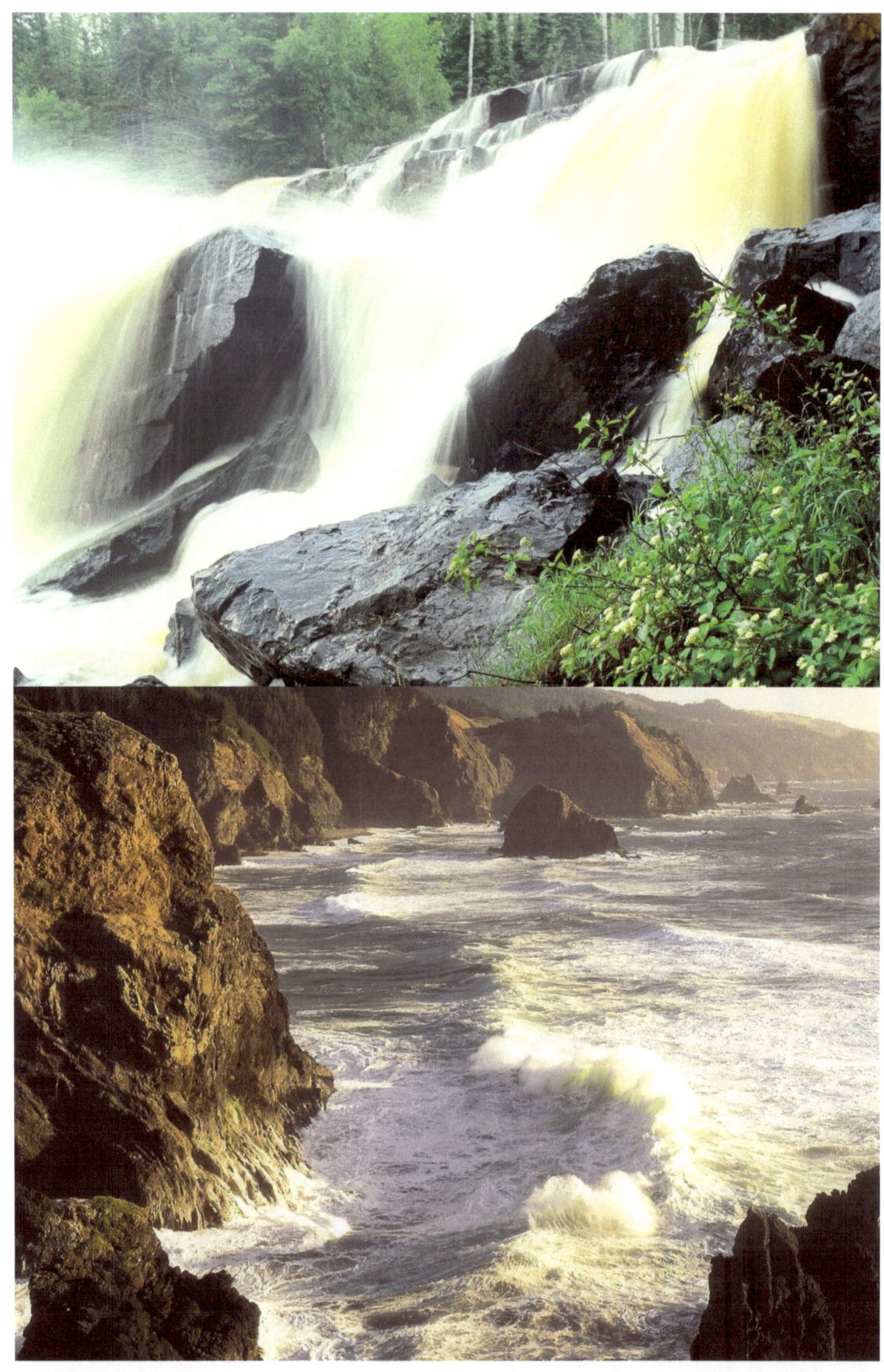

Mother Nature's Best Side A Picture Journey

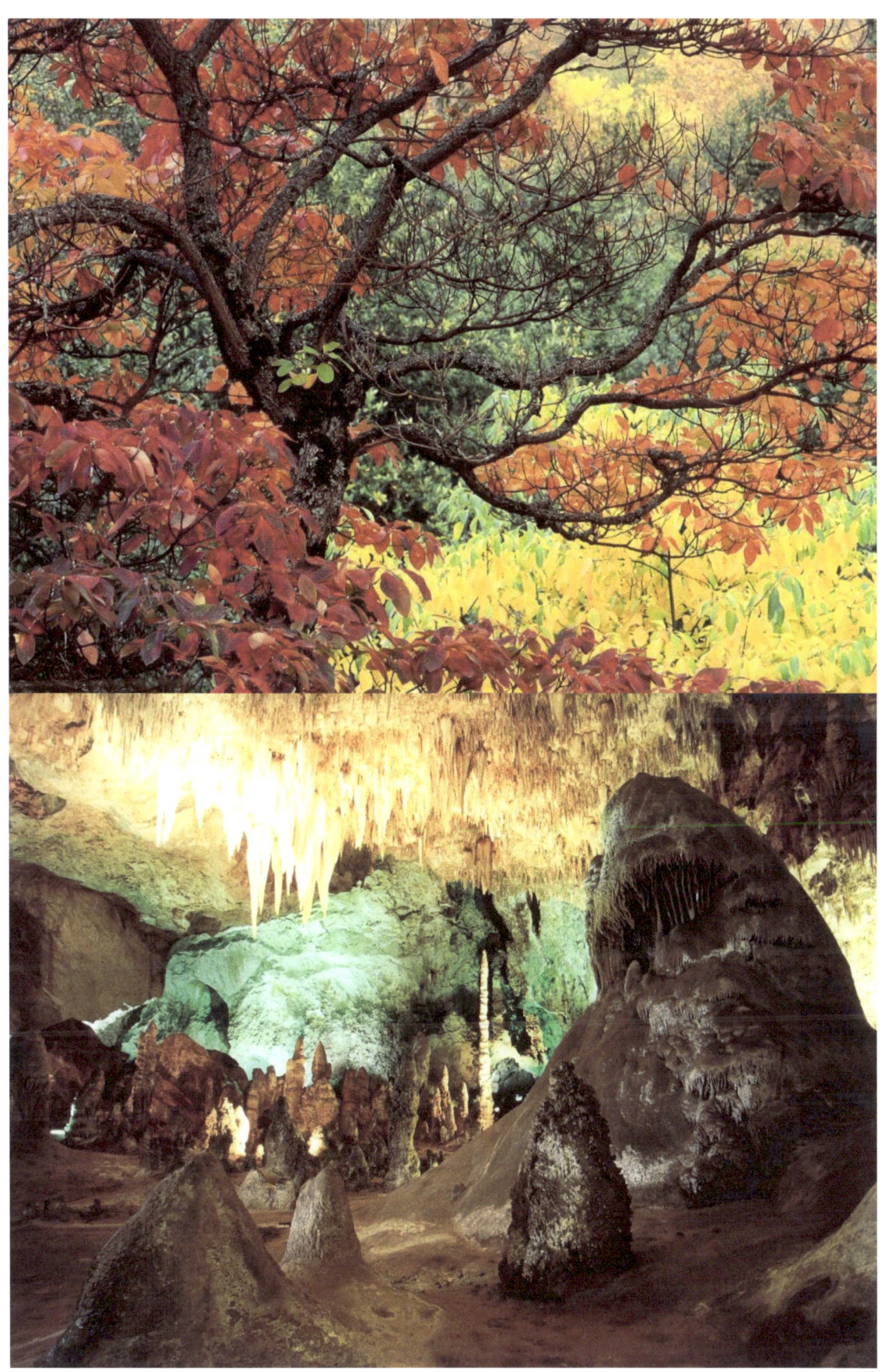

Mother Nature's Best Side A Picture Journey

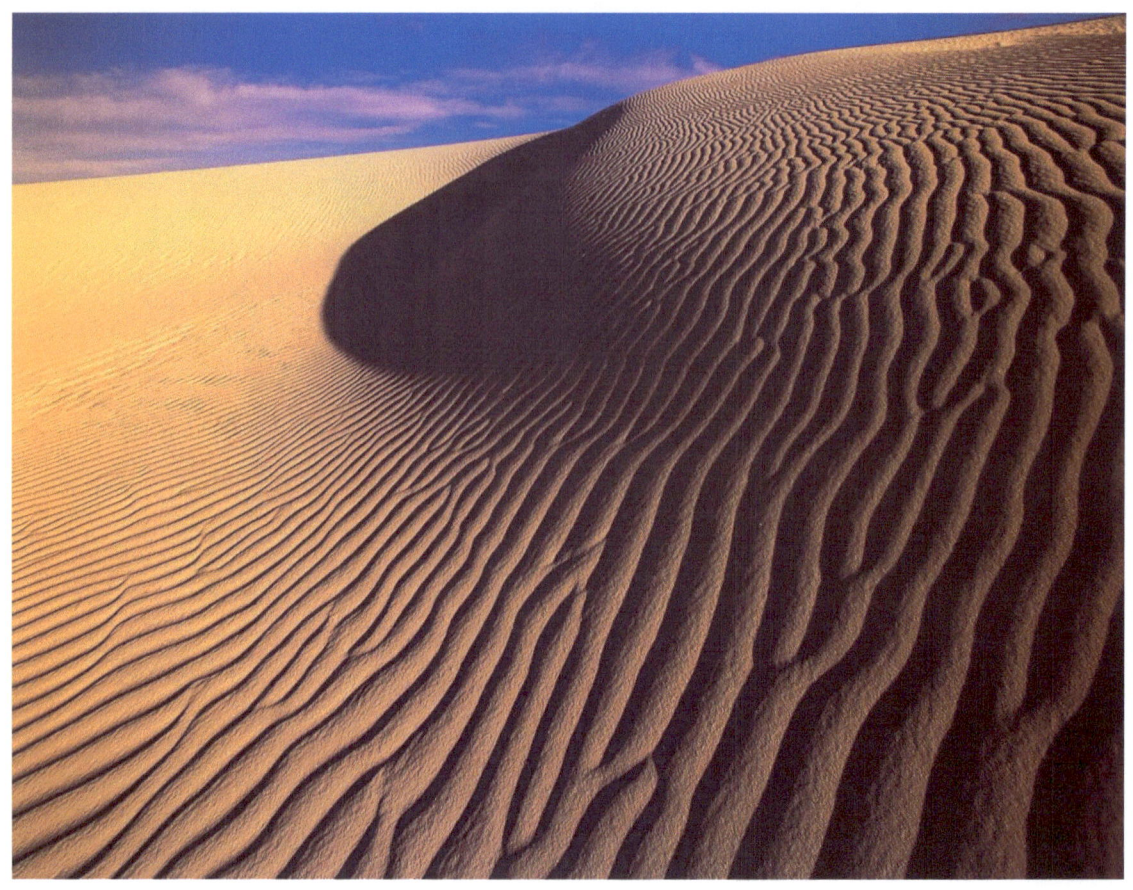

Cathy Cavarzan

Mother Nature's Best Side A Picture Journey

Mother Nature's Best Side A Picture Journey

Mother Nature's Best Side A Picture Journey

www.ingramcontent.com/pod-product-compliance
Lightning Source LLC
Chambersburg PA
CBHW051107180526
45172CB00002B/805